AROUND
FAIRFORD

THROUGH TIME

June Lewis-Jones

AMBERLEY PUBLISHING

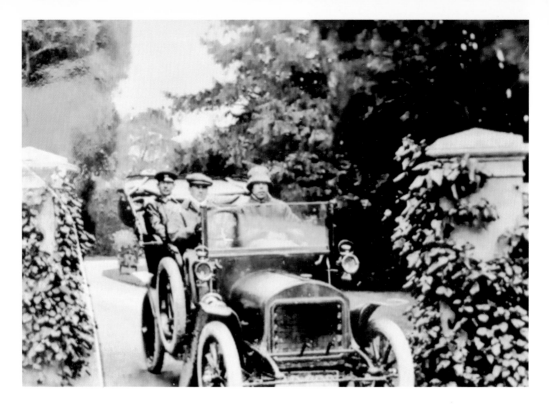

Dr Harold Bloxsome setting off on his rounds from Croft House with his assistant Dr Soowan. Fred Keylock, originally the groom, became the chauffeur as the motor car took over from the horse – he is seen here in his uniform, on the back seat. Dr Harold's father was the first man in Fairford to own a car.

Front cover: Eastleach clapper bridge in the 1960s and in spring 2011.
Back cover: Two Fairford family butcher's: Perry's in 1895 and Andrew Butler's in 2011.

First published 2011

Amberley Publishing
The Hill, Stroud
Gloucestershire GL5 4EP

www.amberleybooks.com

Copyright © June Lewis-Jones 2011

The right of June Lewis-Jones to be identified as the Author of this work has been asserted in accordance with the Copyrights, Designs and Patents Act 1988.

ISBN 978-1-84868-951-0

British Library Cataloguing in Publication Data.
A catalogue record for this book is available from the British Library.

Typeset in 9.5pt on 12pt Celeste.
Typesetting by Amberley Publishing.
Printed in the UK.

Introduction

This is not another history book, rather a pictorial record of how much – or how little – Fairford and seven of its closest neighbouring villages have changed over little more than a century.

I have designed the book as a kind of tour, starting with an approach to Fairford on the A417 from the west. This small, old market town, with a recorded history stretching back some 1,200 years, still has evidence of its medieval street plan. Change is inevitable; not so long ago this was a self-sufficient community. We mourn the loss of the old family-run shops and building firms and the closure of the railway line – which had provided a means of development and expansion beyond the parish boundaries. New uses have been found for old buildings, but it is the people who implement and adapt to the changes – who really weave the weft across the warp of time to produce the fabric of social history and make a place a living community.

Fairford is set in one of the most beautiful parts of the kingdom, in the gentle, rolling foothills of the Coln Valley, and is surrounded by a patchwork of small farmsteads. To meander off to the nearest villages – none more than 4 miles away, and so quintessentially English, so typical of the distinctive Cotswold country with its honey-coloured stone linking communities like a golden thread – is a salve for the rush and tear of modern-day living. But these are not just a chain of sleepy havens to which wealthy weekenders and celebrities are attracted; they still maintain the soul of village life.

Eastleach is a storybook picture of peace and tranquillity where so often the only sound to be heard is the wood pigeons' call in the valley. The Roman Akeman Street has its ancient footprints stamped into the hillside *en route* to Hatherop, where the late thirteenth-century manorial roots of Hatherop Castle share the same hilltop as Williamstrip Park, which leads to Coln St Aldwyns. The River Coln is prominent here as it winds its way through to Quenington. It is to the riverside gardens

of Quenington's Old Rectory that thousands of art lovers flock to the biennial contemporary sculpture show. A cross-country route, by way of rural Donkeywell, leads down to Meysey Hampton, an enclave of traditional farming, and on to Kempsford, with its echoes of the old Thames & Severn Canal almost silenced in the undergrowth – a haven for wildlife. Skirting the boundary of the airfield into the hardly-a-hamlet Whelford, it is but up and over the hill back to Fairford.

Welcome to Fairford
The approach from the Cirencester Road shows the coat of arms of the Tame family – medieval wool merchants who first brought prosperity to the town and paid for the rebuilding of the fifteenth-century church.

Coronation Street

Left at the crossroads, this short street starts at Old Tracey, with its 1607 origins, and terminates at Milton Farm, seen at the far end. It changed its name from Milton End to commemorate the coronation of Edward VII. The picture on the right was captured by a National Geographic photographer in the 1950s. David Pitts with his cousin Paul and two friends are in the picturesque garden of their grandmother, Mrs Acock. The house, Hazelwood on The Green, was once an off-licence.

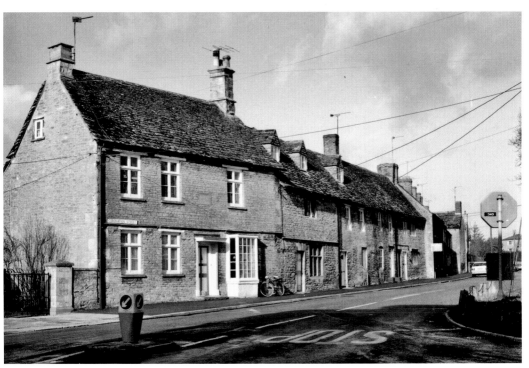

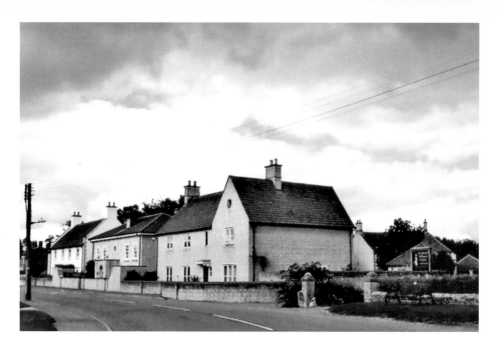

Horcott

The right-hand turn from the crossroads leads through Horcott to RAF Fairford. The Carriers Arms was a popular pub for the thousands of servicemen who were stationed at the base over the years. By 1990 it had closed, and new houses have been built on the site. The gateway to the right of the top picture is the entrance to St Thomas of Canterbury Catholic Church.

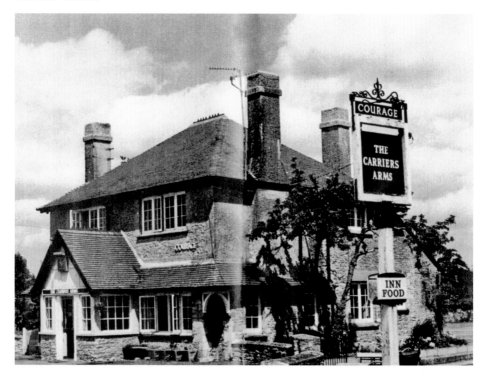

Milton Street

Waterloo Lane leads off Milton Street and follows the brook to meet the River Coln at Horcott. The Lane family is in the top picture, with a portion of Farmer's stonemason's workshed to be seen to the left. Nelson Lane was the last coachman at the Bull Hotel. Julian and Sonia McDermott enjoy the modern extension, left of the original doorway, which allows them full view of their flower-filled garden.

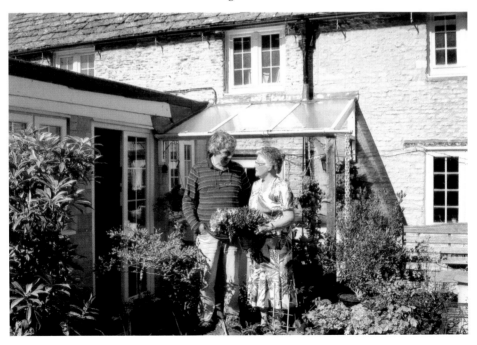

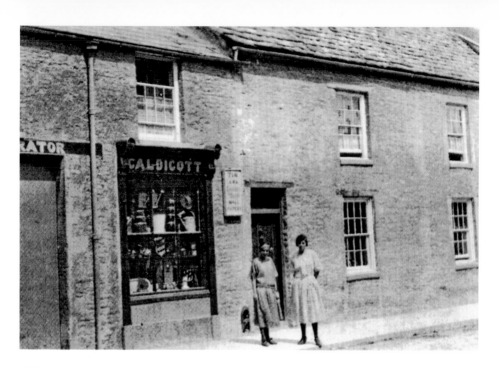

Milton Street

Doris and Mona Caldicott outside their shop in 1920. The Caldicott family were painters, decorators and sign writers and kept a well-stocked hardware store. The shop is now a private house. In the bottom picture, Bert Acock, wears his chauffeur's uniform. He drove the first taxi for Busby's Garage and was the head mechanic.

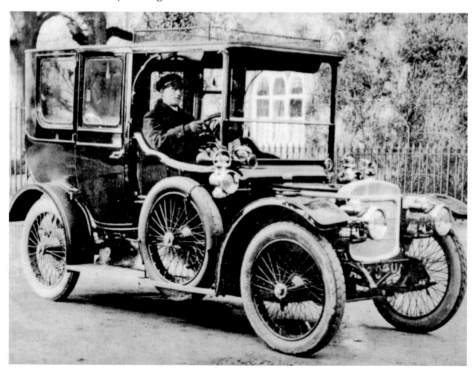

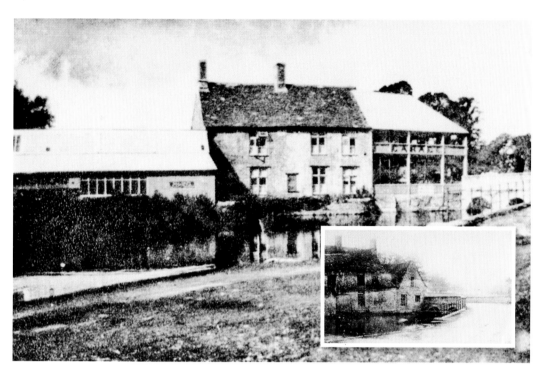

Town Bridge

The old cottage nearest the bridge (inset) was demolished to build the showroom for Constable's carriage works (above), which were in turn removed to create the forecourt of Busby's Garage. Newly built houses now occupy the site alongside the river.

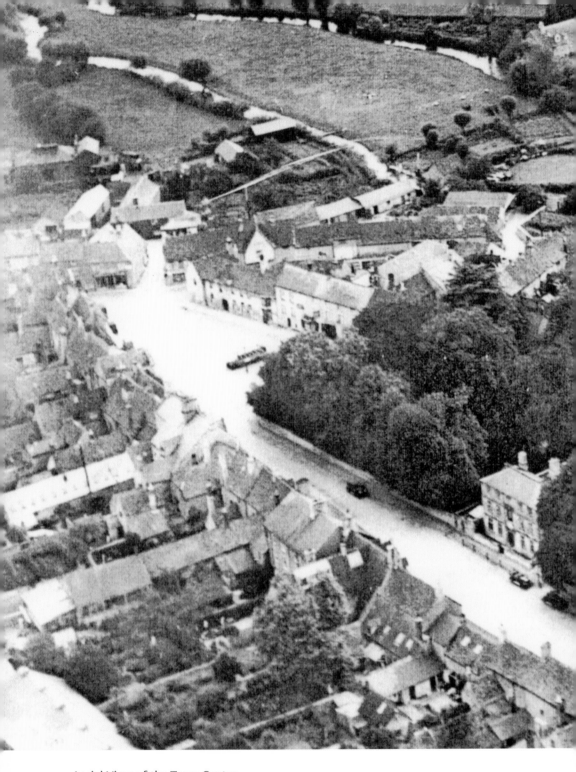

Aerial View of the Town Centre

Judging by the type and small number of vehicles in the High Street, this photograph was taken in the late 1920s. The river can be seen bisecting the town from north to south,

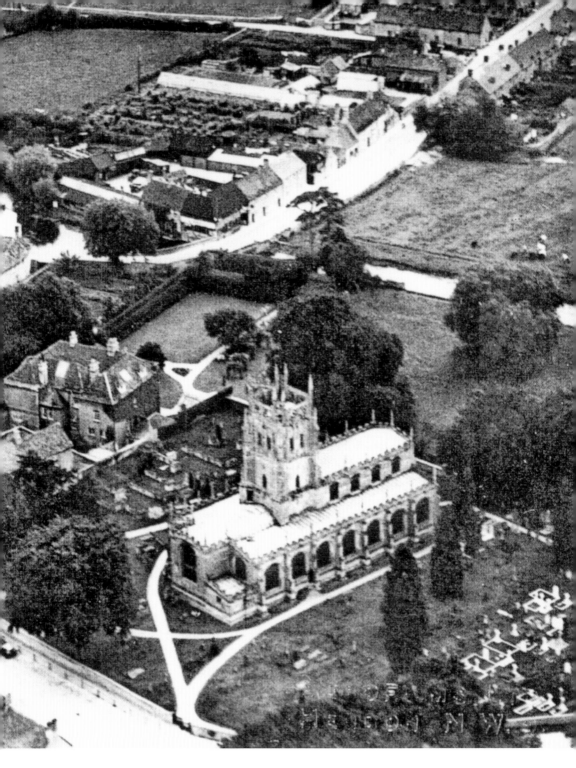

dividing at the town bridge before meeting again at Horcott – leaving a small island called
the Chalice Piece, which was Church land. The old gasworks are about a third of the way
down, on the extreme left.

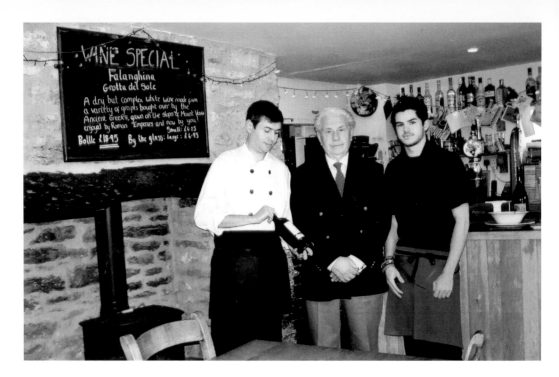

The Bridge

Restaurateur Alessandro D'Elia (left) with his father Leo and son David in the Bridge – the last of the family businesses in the town. Leo brought a taste of Italy to Fairford in 1971 when he and his wife Jane opened his restaurant at the corner of the Market Place. The bottom picture shows the Bridge restaurant when it was Stevens's bicycle shop. There are hand-cranked petrol (or paraffin) pumps in the alcove.

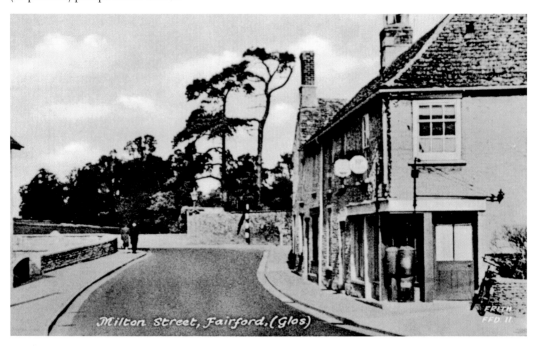

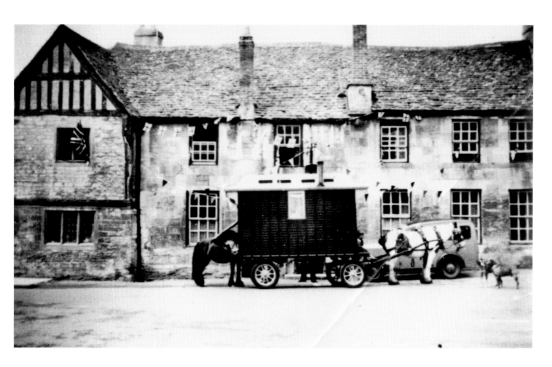

Bottom of Market Place

In the top picture, the George Inn – which dates back to Tudor times, when it was a chantry house for the church – is decked out with bunting for the coronation in 1953, with a horse-drawn shepherd-hut-type caravan outside. The inn is now the post office. The White Hart Inn, opposite, was built as cottages for the masons who built the church in the fifteenth century. Since the inn's closure, it has reverted to cottages again.

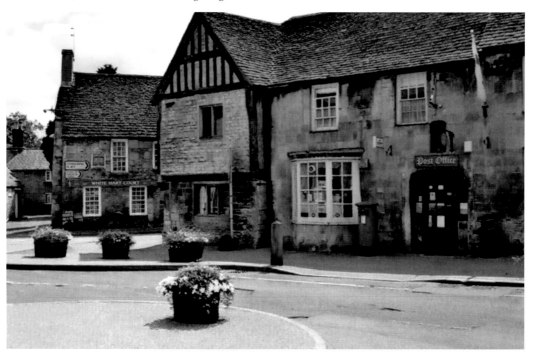

Gas Lane

Nash Court, in the top picture, is one of the houses built on the site of the old Fairford gasworks, which were run by the Nash family from 1852 until they closed in 1936. John Nash (sitting on a barrel at the corner of the house) and his wife (far right) are pictured in 1904 with five of their twenty-one children.

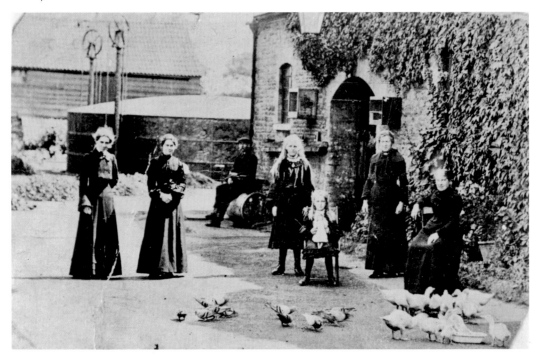

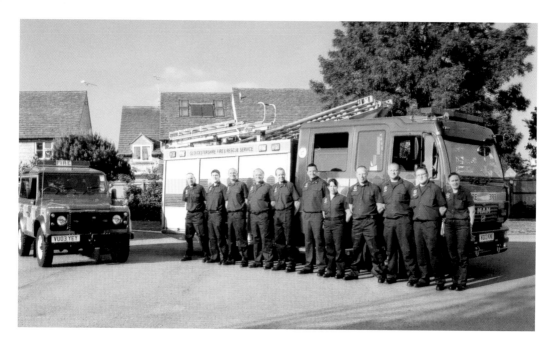

Fairford Fire Service

Eleven of the thirteen Fire and Rescue Service crew in the yard of the fire station in Hatherop Road. The scene is a far cry from the one below, which shows the fire brigade attending the 1909 Fairford Carnival in full uniform. Catching the horse (which was kept in an open shed at the White Hart Inn), harnessing it to the cart, filling the water tank and loading a barrel of beer took up precious time before they could start off.

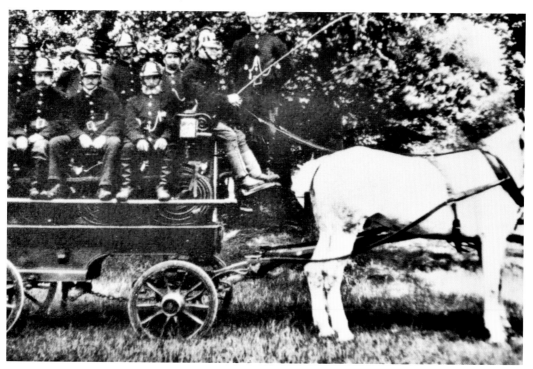

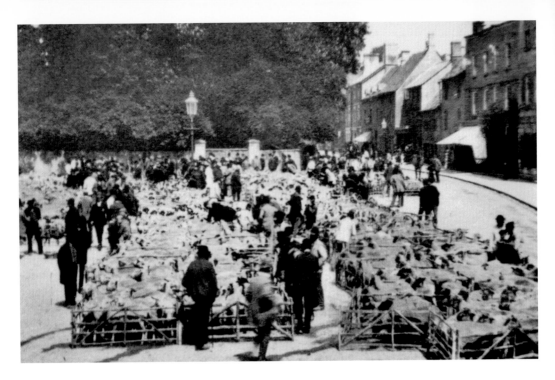

Market Day
The livestock market increased in scope and size after the railway came to Fairford. Sheep were penned in the Market Place, as shown here in 1900. Pigs were opposite the bank, with cattle outside the old school. Horses were in Park Street. Henry Whiteman of Cote Mill stands proudly with his cow and calf outside the church in the mid-1930s. The market closed at the start of the Second World War.

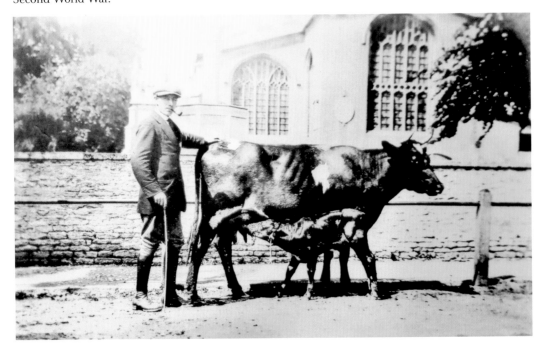

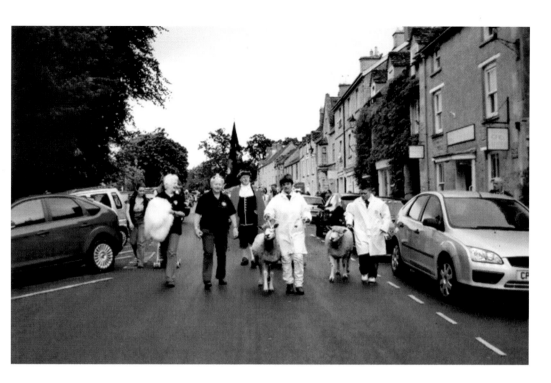

Market Place as a Meeting Place

Frances Whiteman (carrying a fleece), Margaret Pursch (shepherdess), Maurice Jones (town crier), two Cotswold sheep and their gallant handlers head the procession down the High Street to the Market Place, where the national Town Criers' Competition was held in 2010. Fairford has had a town crier since the eighteenth century. Maurice's 'cried' entry speech described how the wealth from the medieval sheep trade financed the rebuilding of St Mary's church.

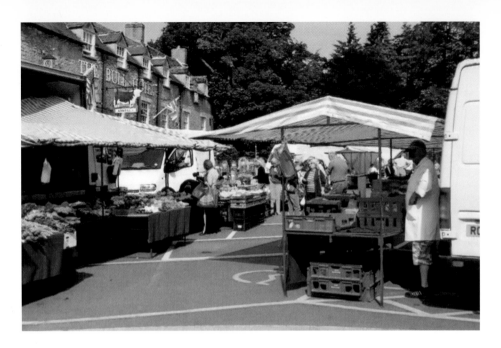

Market Day Today

The weekly open-air market opened in 1986. The Bull Hotel, once an important post house in the coaching era with stabling for thirty horses, makes a picturesque backdrop. Below, Coln House School carol singers bring a note of Christmas cheer to a wet market day in December. The top of the half-timbered old George Inn is on the right and the restaurant – once Leo's – stands squarely in the middle.

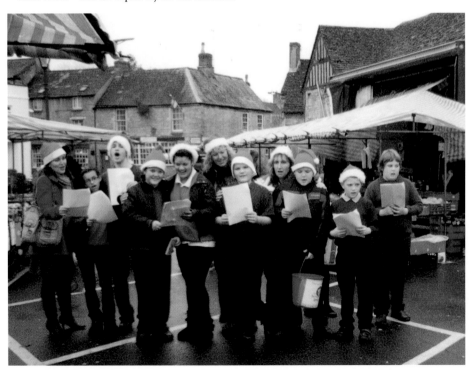

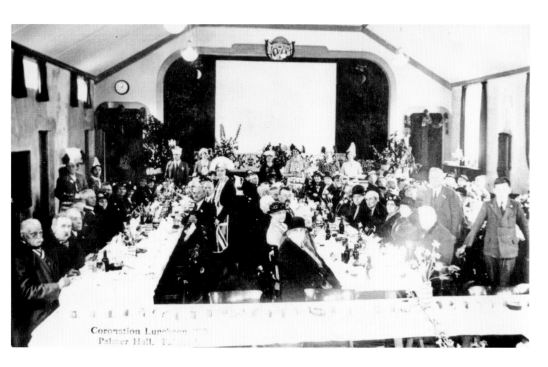

Coronation Luncheon
Palmer Hall,

Celebrations

The coronation of George VI in 1937 was celebrated by a dinner in the Palmer Hall. The hall was given to the town by Col. Palmer to mark the Silver Jubilee of George V. The ox was roasted in the grounds of Morgan Hall. The fiftieth anniversary of VE Day in 1995 was celebrated in colourful style in a marquee that filled the Market Place (below).

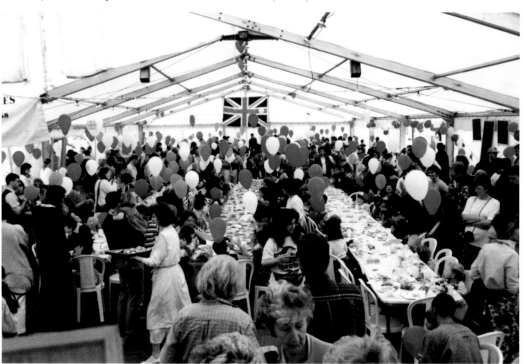

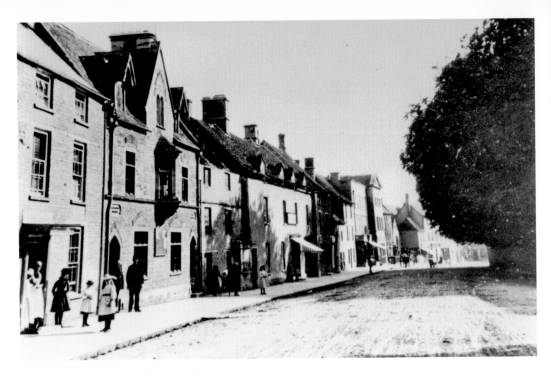

High Street

The top picture, taken in 1896, shows Montague House in the foreground. For a short while it was a children's convalescent home. Next to it is the Victorian police station. Beyond the Big Alley, the short and tall houses next to each other were demolished to build Lloyds Bank and the post office. As can be seen from the contemporary view (looking the other way), little has changed except the use of some of the shops and the police station.

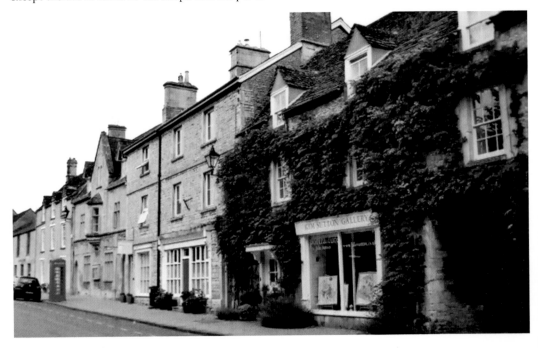

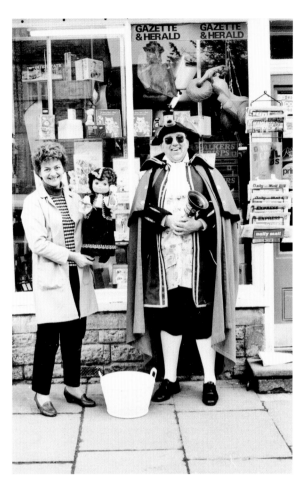

From Fishing Tackle to Fireworks
A. E. Powell, stationer's and newsagent's, is seen below decorated for carnival time. From 1905, it was run by three generations of the Powell family for seventy-one years. In the early days it sold fishing tackle and medical supplies. Charles Powell was the official town photographer; his daughter Heather extended the shop and ran it until 1976. Philip and Elizabeth Hope continued the business until 1997. Right, Liz is seen outside the shop with the town crier.

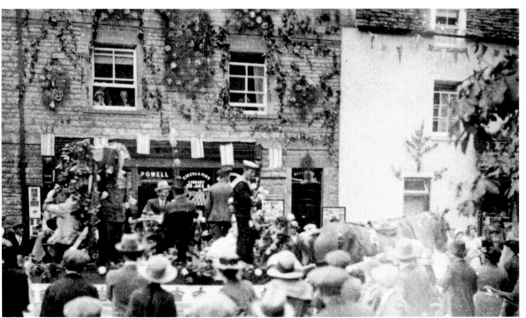

From Drugstore to Deli
Thomas Powell's shop in the Market Place has seen many changes since the photograph below was taken, but externally it has remained much the same. The railings alongside became scrap iron for the war effort.

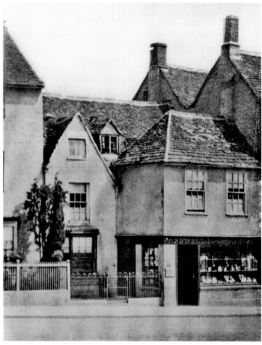

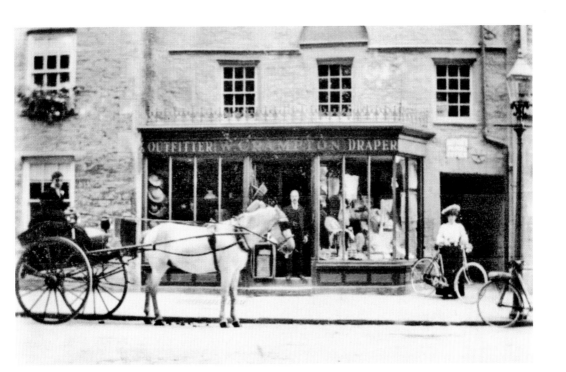

High Street Fashion

W. Crampton in the doorway of his outfitter's and draper's shop, with his son in the pony trap and daughter Ethel with bicycle, *c.* 1900. Baden Powell continued the same line of business, adding toys and jewellery and clock repairs to the range. He is pictured below with Mrs Winifred Beese assisting him as he serves Ros Flatman (with son Thomas) and her sister Judy Brown (with daughter Vicki) in 1982.

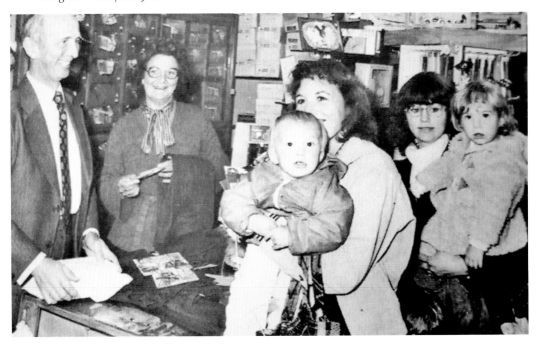

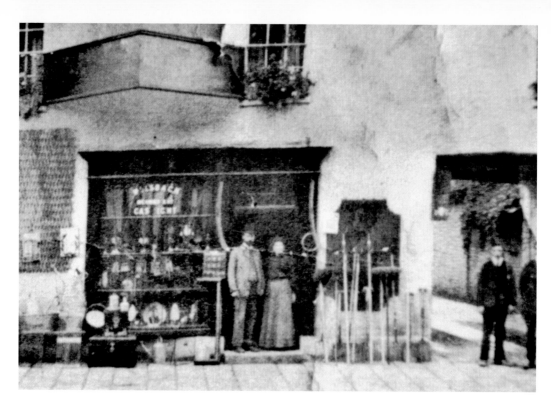

The Shop by the Big Alley

The Baldwin family outside their hardware shop in 1915. Baldwin's was a busy building firm and local undertakers. Coffins were made in the top-floor workshop behind the shop in the Big Alley that leads to The Croft. Below are Mrs Clem Peyman and Michael in the 1990s. Michael and his twin brother Anthony ran the shop with their father and also had a painting and decorating business. The shop is now an art gallery.

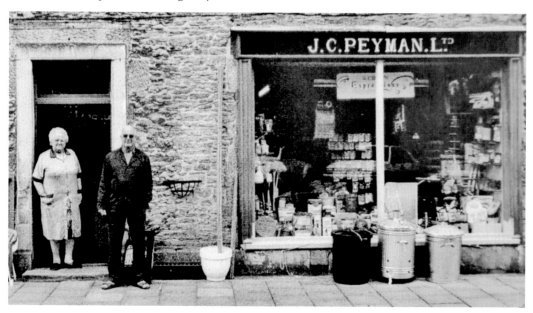

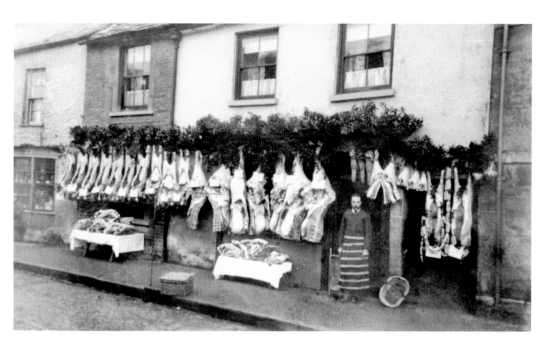

Family Butcher's

The health-and-safety brigade would faint at the sight of the joints openly displayed outside Perry's butcher's shop in London Street for the Christmas show in 1895. A man often stood in the small alley with a whip to keep any stray dogs at bay. What a contrast to today in Andrew Butler's shop in the Market Place, with its splendid range of local produce prepared to customers' requirements – a treasure in this fast-food world.

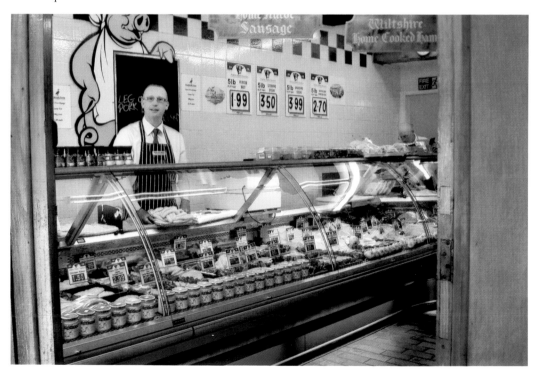

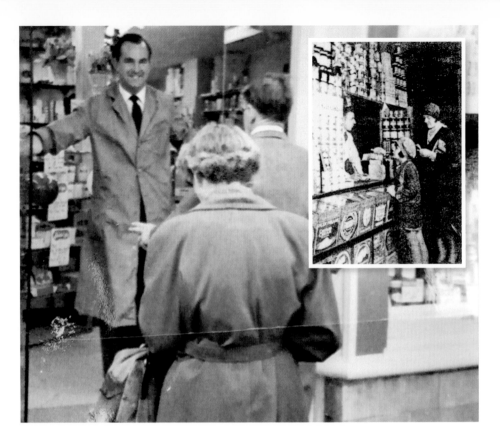

Family Grocers

In Bridges grocery store in the 1930s (inset) the assistant served through a precarious stack of boxes, bottles, cans, and jars. Left, Dennis Bridges greets the first customers to his modernised self-service store – innovative for Fairford – in 1963.

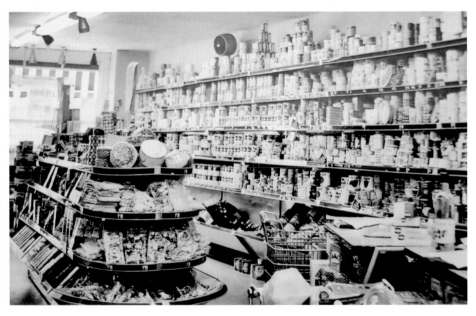

The Croft

The Crampton family, together with Fred and Gertie Keylock, in the backyard of their High Street shop in 1900. It is now the home of Martin and Diana Lee-Browne. Diana is a sculptor and letter-cutter; here she is working on the Duke of Edinburgh's Royal Regiment panel, one of six panels designed for a stone memorial at the Memorial Arboretum at Alrewas in Staffordshire. One of the panels is dedicated to the Glorious Glosters, with its famous back badge. The memorial was unveiled by the Queen in July 2011.

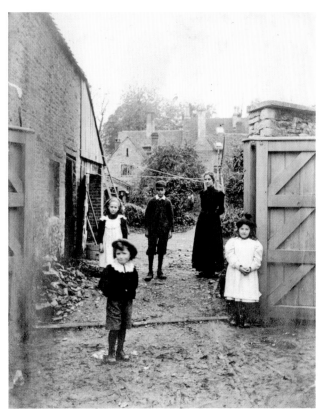

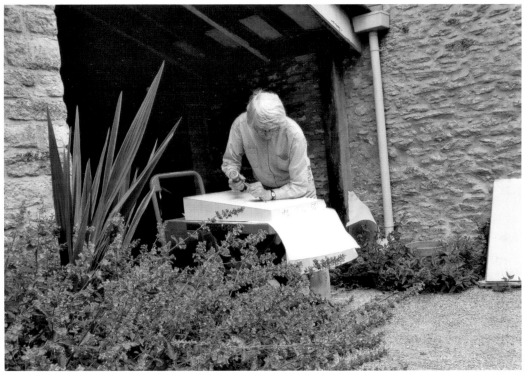

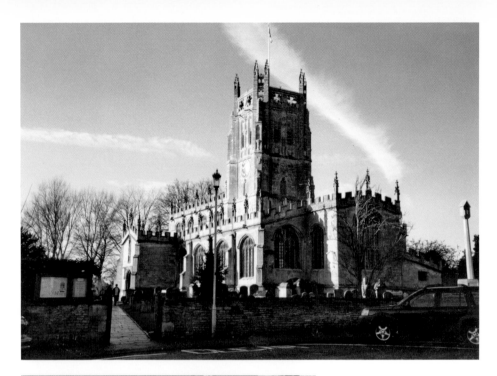

St Mary's Church

One of the famous 'wool' churches, St Mary's was consecrated in 1497. The elegant war memorial was designed by Ernest Gimson in 1919. The stone pinnacles stand crisply against a blue summer sky, with a unique climbing-boy sculpture on the parapet (below) – all the work of Peter Juggins, the stonemason who replaced the entire set of pinnacles that were destroyed in a freak whirlwind in 1971.

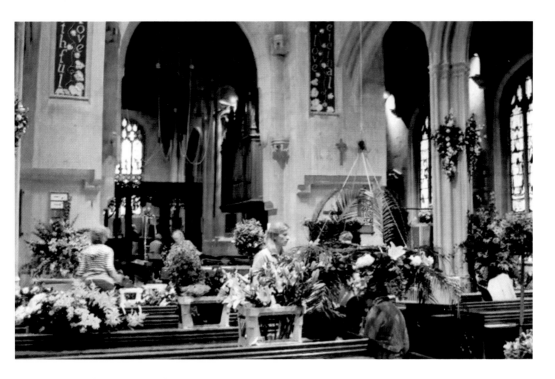

The Windows Restored

The completion of the twenty-five-year restoration programme of the set of twenty-eight medieval stained-glass windows (St Mary's being the only church in England to have retained its original set of that age) was celebrated in June 2010. A glorious flower festival was staged to celebrate the return of the final two windows. Above, preparations to fill the church with flower arrangements inspired by the artistry of the glowing glass are underway.

Farmor's School
Elizabeth Farmor, granddaughter of the lord of the manor, left a considerable legacy for 'the Benefit of a Free School to be taught within the parish of Fairford'. Fairford Free School, shown below, opened its doors to the first sixty 'poor boys of the parish' on 24 November 1738. It is now the town's community centre; the school moved to new premises in Fairford Park in 1961.

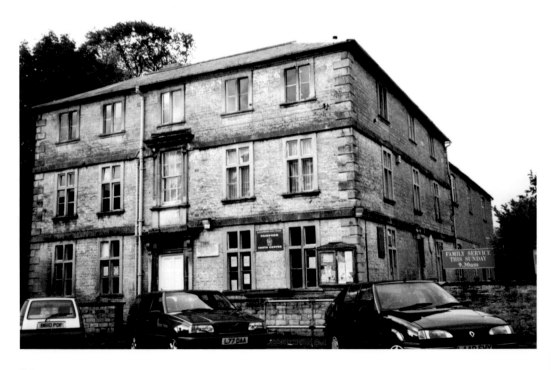

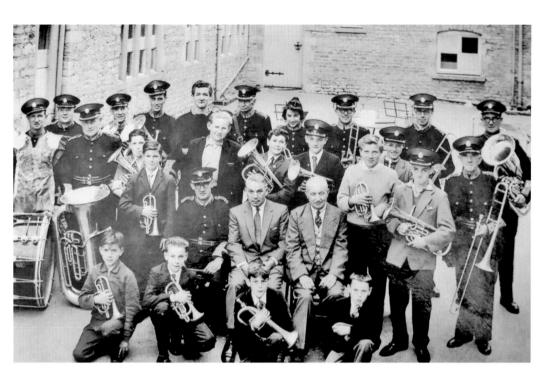

Still Serving the Community

Fairford Silver Band used the old Farmor's School for its practice sessions. Here they are in the playground, which was divided by a stone wall to separate the boys from the girls. After a £1.3 million restoration and extension, the community centre re-opened in 2008. Its design and management were recognised with a Hallmark Award in 2010. The glass corridor, linking the old building with the new extensions, provides an attractive reception area.

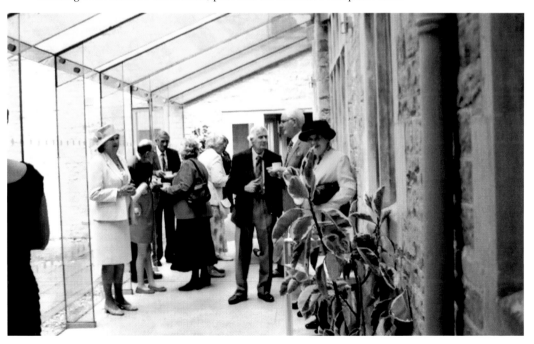

Church Vergers

Above, Richard Kimber at St Mary's church in 1896. He holds the fishing rod he used to point out the features in the windows. The tip was covered with chamois leather so that it did not scratch the glass. Below is Sid Jacques in 1994 with the tombstone to Tiddles, the church cat of seventeen years. It was this kindly verger who requested that Tiddles should be buried in the churchyard and paid for her memorial.

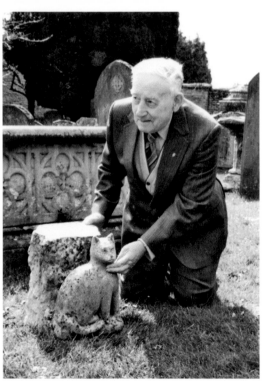

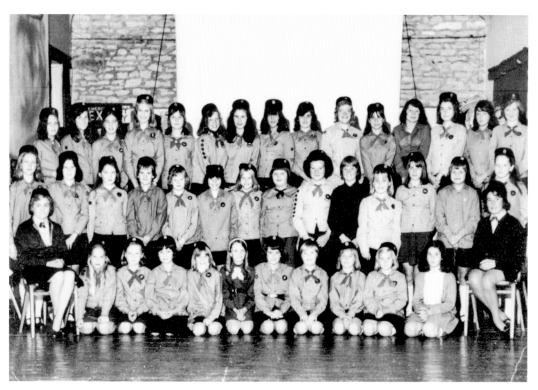

Serving the Youth
Sonia McDermott (seated far right) with
a group of 1st Fairford Guides in the
mid-1970s. Youth leader Geoff Chick,
below, lived with his family at the old
Farmor's School after it became the
Community Centre. Commemorating
his lifetime's work for the community,
the youth in particular, an annual Geoff
Chick Award has been created for young
people who have done good work in the
community.

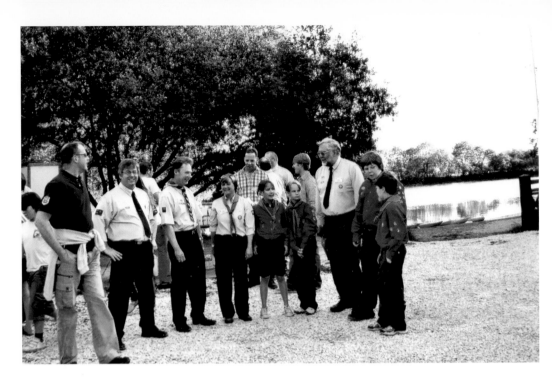

1st Fairford Scout Group

The Scout group at Fairford includes girls and is reportedly the most thriving group in the Cotswolds. An open evening was held in June 2011 to show parents and leaders the newly refurbished Scout Hut at Horcott Lakes. The idyllic setting offers a wide range of activities. Scout leader Mark Bridges, below, gives instruction to three Scouts eager to try their hand at canoeing.

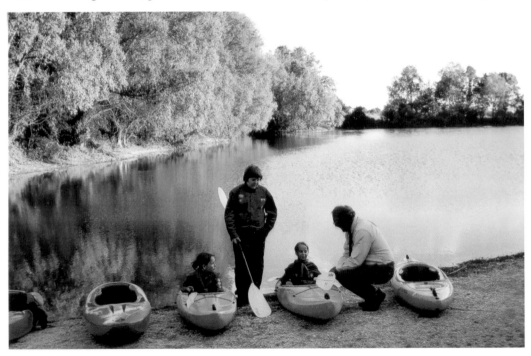

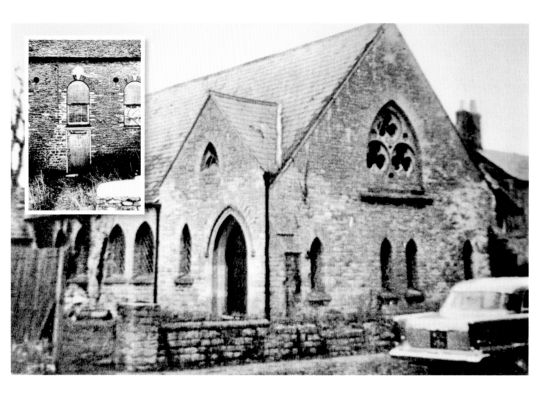

Chapel Days

The Congregational Chapel in the Croft (top) was built in 1862 and demolished in 1965. The inset picture shows the old Primitive Methodist Chapel in Milton Place; after its closure in the 1920s it served as a hall for the 1st Fairford Scouts and Girl Guides. It has now reverted back to a cottage. The Baptist Chapel in Milton Street, shown decorated for its flower festival in 2010, is now the United Church, amalgamating all the Nonconformists.

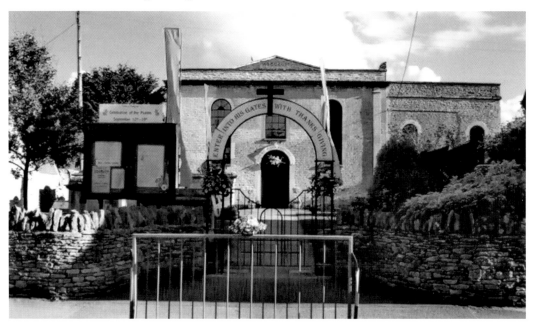

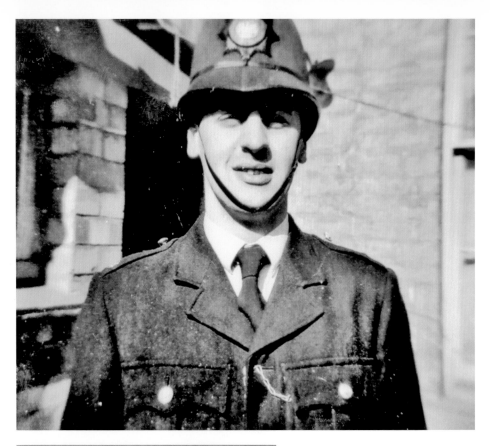

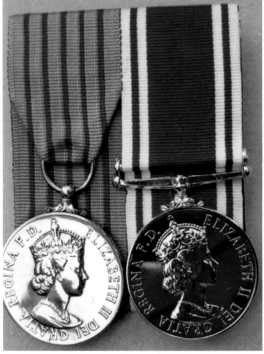

The George Medal and Service Medal for a Local Hero

On 16 March 1961, PC David Smeeton drove his colleague PC Ronald Spencer to Down Ampney in answer to a call. When they arrived at the house they were confronted by a Polish man holding a gun. PC Spencer received a shot in the chest and PC Smeeton tried to stop the Pole turning the gun on himself. The pair fell against the furniture and fought across the two bodies that were lying on the floor. PC Smeeton wrenched the gun from the Pole's hands, and then gave chase as the killer escaped through the back door. He then wrenched a gate from its hinges and threw it at PC Smeeton. Several men from the village joined in the chase. The Pole was finally tripped up by Mrs Evans, a neighbour, and PC Smeeton was able to put him in handcuffs.

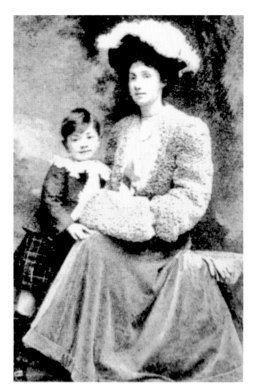

A Lifeboat Number for a *Titanic* Heroine

The memorial plaque in St Mary's church to Noelle, widow of the Earl of Rothes, gives no indication that it commemorates a heroine of the *Titanic* disaster, which had earned her the title 'the plucky little countess'. After the widowed countess married Col. Claud MacFie, they lived at Fayre Court in Milton Street, where local people remembered her as a very kind, petite and attractive lady. Seaman Jones later gave her the Lifeboat Number 8 plaque as a memento of that disastrous night in 1912, when she bravely took the tiller of the lifeboat and comforted the women and children as the *Titanic* sank. Noelle is seen here with her small son.

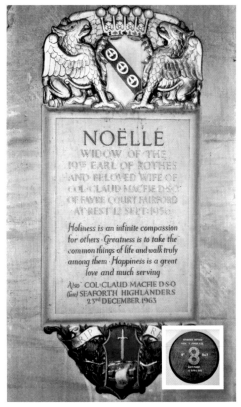

NOËLLE
WIDOW OF THE
19TH EARL OF ROTHES
AND BELOVED WIFE OF
COL·CLAUD MACFIE DSO
OF FAYRE COURT FAIRFORD
AT REST 12 SEPT·1956

Holiness is an infinite compassion for others · Greatness is to take the common things of life and walk truly among them · Happiness is a great love and much serving

Also COL·CLAUD MACFIE D·S·O
(late) SEAFORTH HIGHLANDERS
23RD DECEMBER 1963

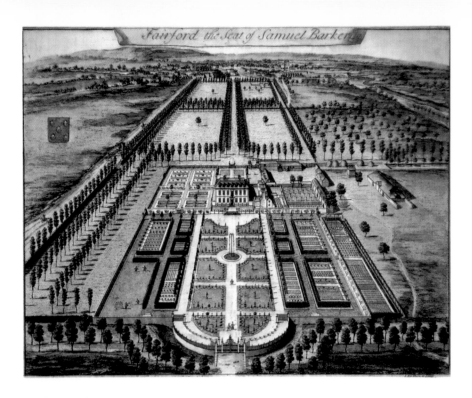

Fairford Park

Kip's 1720 engraving (above) is of Park House, built in 1660 for Samuel Barker, Lord of the Manor. The formal landscaping of the gardens was to the north of the house, with tree-lined avenues leading southward to the town. The aerial view of 1952 shows the eighteenth-century extension to the house and the rows of Nissen huts of the 186th USAF General Hospital. In 1947–59, it served as a Polish hostel.

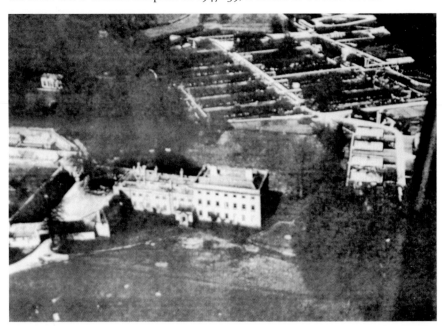

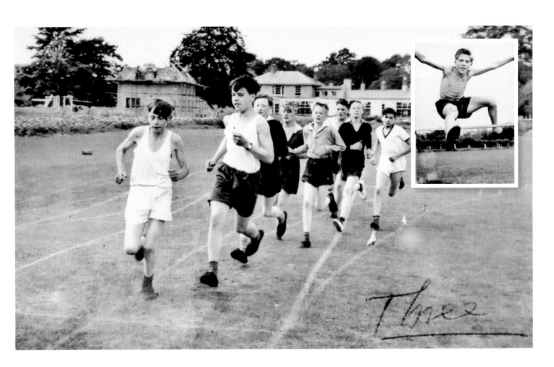

Sporting Boys of Farmor's School

Farmor's School used the playing field of Coln House School at Horcott for team games and sports days, since there was no space at the old school in the High Street. Inset is Marian Walecki, one of the school's high fliers, in action in 1959. The new school, built in the park on the site of the old manor house, has, in the fully equipped gym, space to swing and climb.

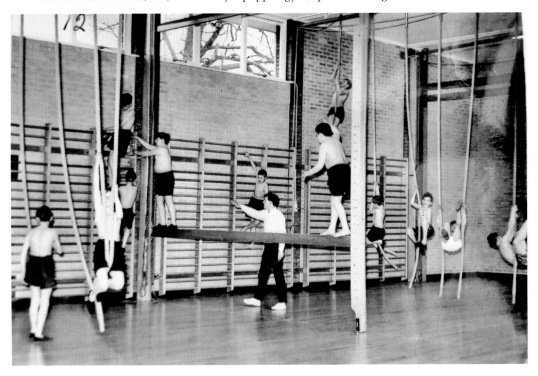

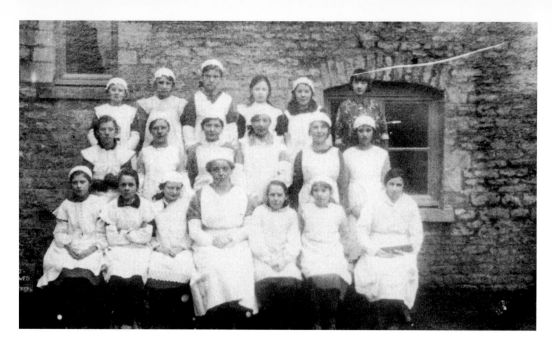

Cookery for the Girls

Mrs Nora Cheales with her cookery class in 1922. As there were no facilities at the old school, the girls had to walk up to Milton Hall (next to the Marlborough Arms), where they cooked on primus stoves and fetched water from a well at the back. Mrs Jean Mattock's class is all smiles as the efforts in the 1966 Christmas cake competition are displayed.

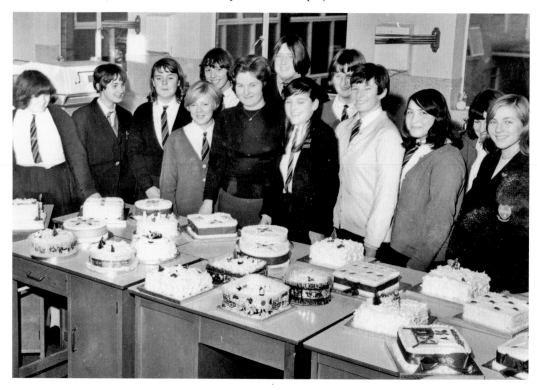

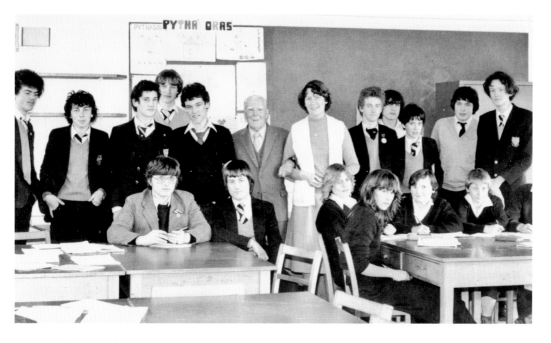

Magical Numbers

Miss Audrey Wright introduces the 100-year-old Mr Hedges, once the headteacher at Farmor's School, to her mathematics class in 1981. Below, Mrs Anne Newman, on the left, demonstrates the fun of figures to Fairford Pre-School children in the magical setting of the woodland classroom. This is an integral part of the Ernest Cook Trust educational programme, which serves around fifty local schools.

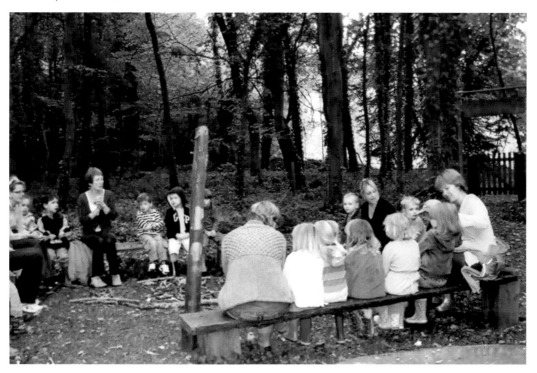

All Change for the Playing Field

Temporary prefabricated classrooms can be seen in the background. The primary school needed additional classrooms when it outgrew its original building in the Croft. After the school moved to Fairford Park in 1987, the site became a small housing development called The Orchard (it had been part of Keble House orchard back in the eighteenth century). This now provides a roadway from the Croft to the library.

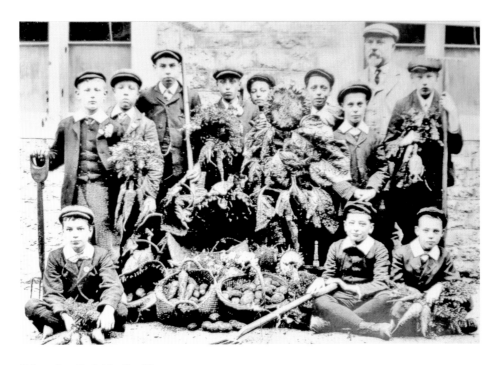

Education Outside the Classroom

Farmor's boys in 1907 with their prize-winning crop from the school garden at West End. Below, Fairford Primary School has won its second eco-flag for its commitment to a sustainable and eco-friendly lifestyle. Mrs Bonnie Martin, head chicken-keeper/goatherd for the school, oversees all animal-based activities. Six of today's twenty-one chickens are ex-battery hens. The livestock provides a basis for concepts of maths, animal husbandry, nutrition, cookery, literacy and art.

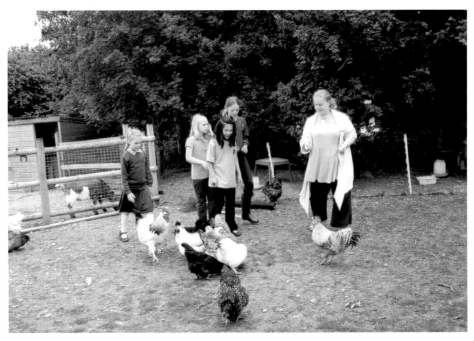

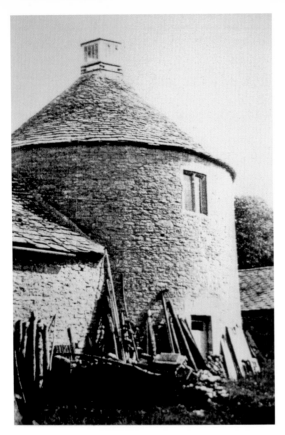

Building Styles, Old and New

The dovecote in Park Street dates back to *c.* 1600. There is a central column of nesting holes, and square nesting holes line the inner walls. The design of the town library, below, echoes that of the old infant school. Built in 1873, it incorporates the old and the new; it is an attractive and well-used facility. The Cotswold dry-stone walls of the alley are a prominent feature throughout the town.

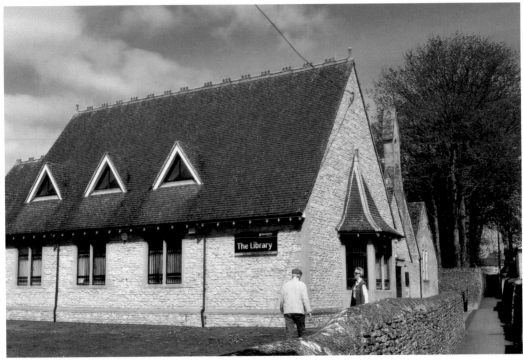

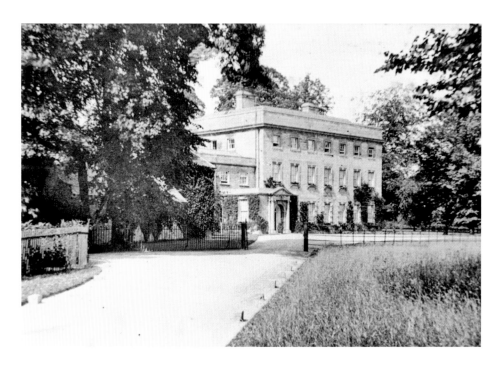

Great Houses Replaced and Restored

Park House in 1920. The seat of the Barker family for almost three centuries, it was demolished in the 1950s. Farmor's School now stands on the site. The remaining courtyard buildings are now the headquarters of the Ernest Cook Trust. Below is Barry Fenby at Morgan Hall, once the Barker's Dower House, which he has lovingly restored, enhancing its Elizabethan origins. The ha-ha where Barry is standing is an eighteenth-century feature separating the parkland from the garden.

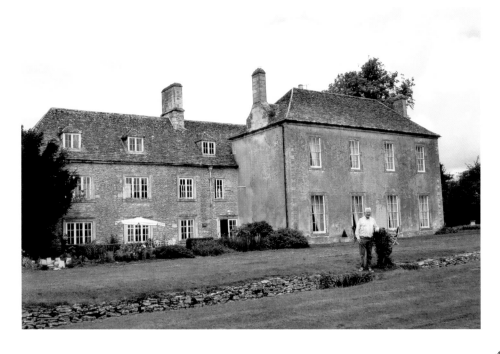

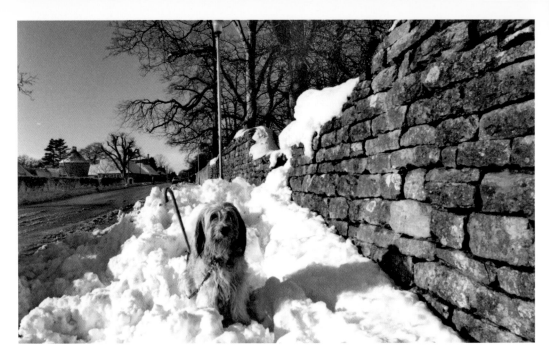

Winter's Wrath
Pethera, my Polish sheepdog, poses patiently in the snow in Park Street in 1990. Below, the Coln breaks its banks across Mill Lane gardens and The Green in 2000.

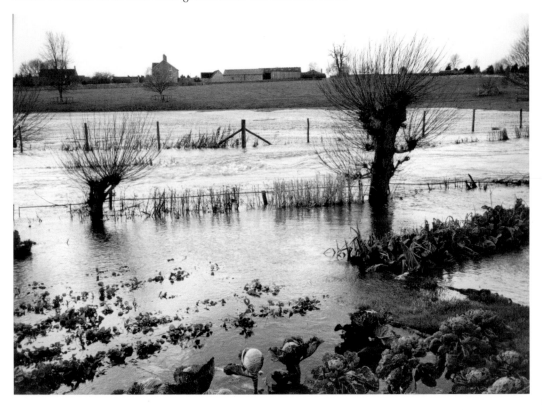

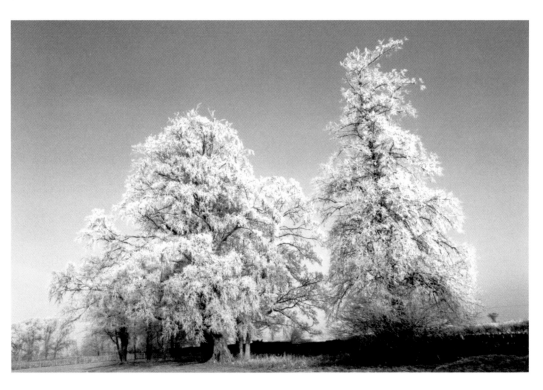

Winter's Beauty
Below, the old mill in 2005, with the church in the background – picturesque as a Christmas card.
Above, hoar frost weaves its ice-fingered magic over the trees in Fairford Park in 2010.

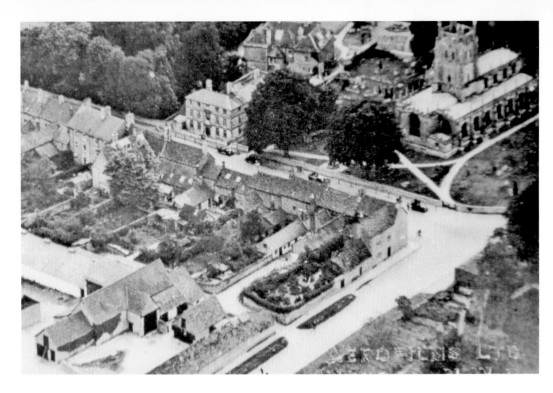

Park Farm and Street

This aerial view of the top of the High Street shows the great barn and yard sheds of Park Farm in the lower left of the picture. These were demolished when the farm closed, with the exception of the half-timbered wool store, which has been incorporated into the houses built on the site. The four eighteenth-century cottages at the end of the terrace below became Fairford's first cottage hospital from 1867 to 1887.

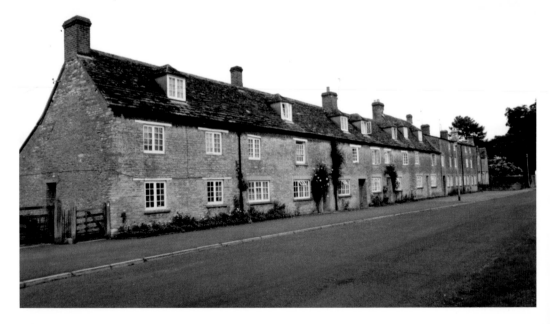

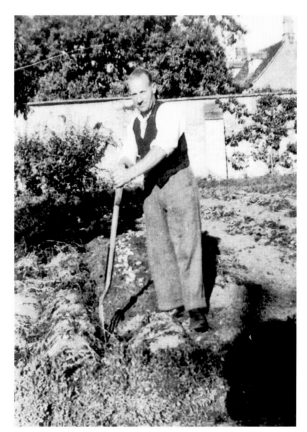

Vicarage to Care Home

The Hyperion Care Home in London Street, shown below with extensions and conservatory, was once the vicarage. In the above picture, Noah Clements, gardener for the Revd Gibbs, is digging potatoes in the vegetable garden – Tithe Barn House is built on the site. The short buttresses against the back wall of the garden mark the site of the old tithe barn; the large tree behind the wall was an ancient mulberry.

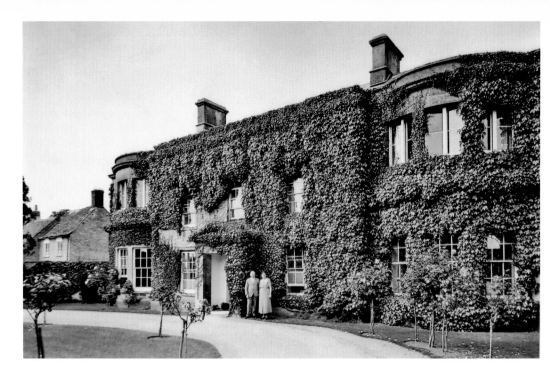

Croft House and Cottage Hospital
Dr Harold Bloxsome and his wife at their home, Croft House, *c.* 1930. Following his father into the practice, Dr Harold held his surgery here. Fairford Hospital, much extended since it was built in 1887, closed its doors to in-patients in 2006 but, thanks to the stalwart support of the League of Friends and the community in general, it still fulfils a vital medical service with specialist and treatment clinics.

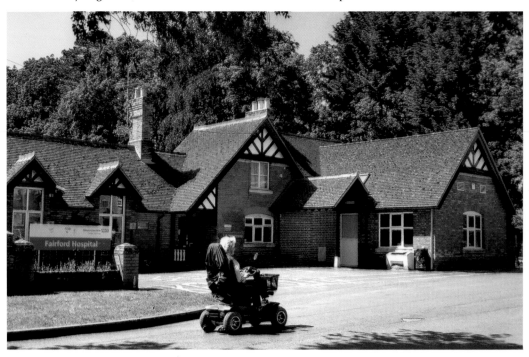

Drs Shaw and Veale at Hilary Cottage Surgery, 1950–84

Dr Charlton Shaw took over the practice from Dr Bloxsome in 1950 and was joined by Dr Michael Veale six months later. Their outstanding contribution to the community is summarised in the photographic tribute showing them in naval uniform when they took over the practice, and, later, when they cut the first sod for the new surgery in 1984. They died within six months of each other in 2008. Below, on the day of his retirement in May 2010, Dr Guy Knights receives the picture from Lt-Col. Robert Shaw, Mrs Angela Veale and her son, Richard. The tribute hangs in the foyer of Hilary Cottage Surgery, together with a photographic montage of previous doctors and Fairford characters assembled by Dr Shaw.

MEDICVM OPTIMVS ET HOMINVM

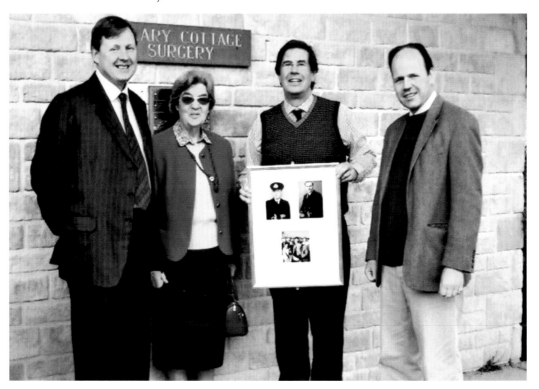

51

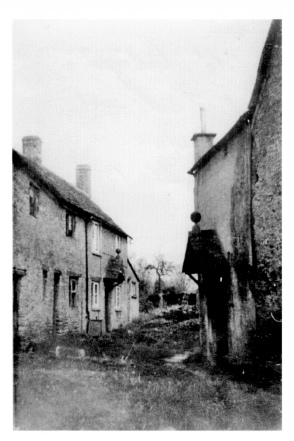

East End
Derelict cottages at East End, pictured here in 1966, were demolished to clear a site for Fairford's first purpose-built surgery, which took its name from Hilary Cottage, the converted Ebenezer Chapel in Coronation Street where the practice was held following the death of Dr Bloxsome and the sale of Croft House.

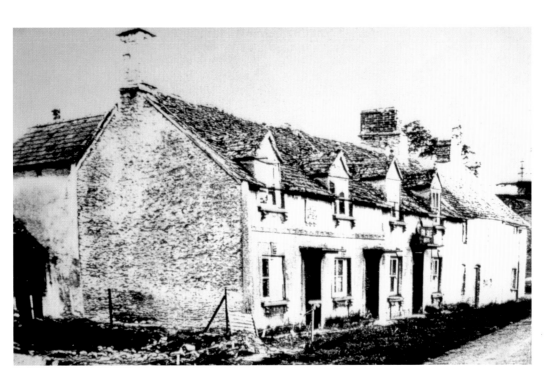

From Dereliction to Des Res at East End

It was to prevent the demolition of this row of cottages that Dr Shaw founded the Fairford Preservation Trust in 1965. Today, these pretty cottages all in a row are an attractive example of how sympathetic restoration and tender loving care can turn an eyesore into a country dweller's dream.

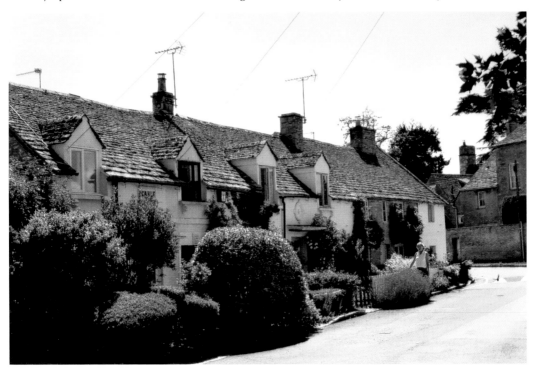

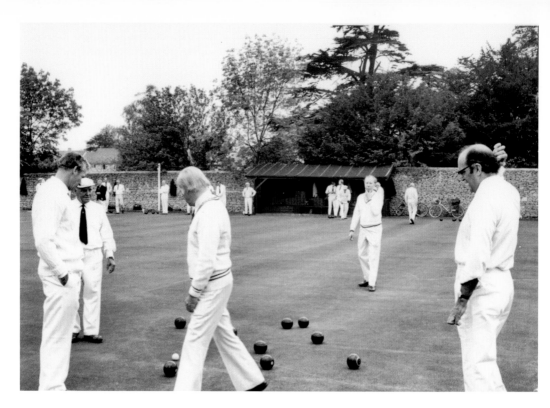

Fairford Bowling Club

Bowls have been played at Fairford since 1700, but the first club was founded in 1914 using the cricket ground in Park Street. Soon after the First World War, the club moved to East End and in the top picture, taken in the 1980s, the first pavilion – the lean-to in the background – can be seen. The new clubhouse opened in 1974 and the splendid facilities make this one of the most popular clubs in the county.

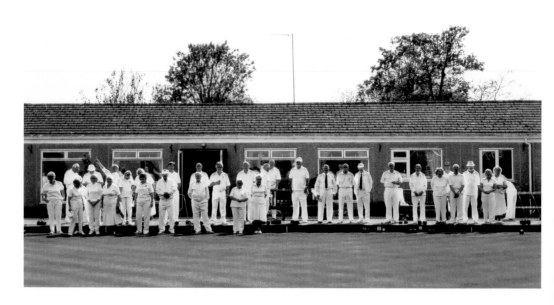

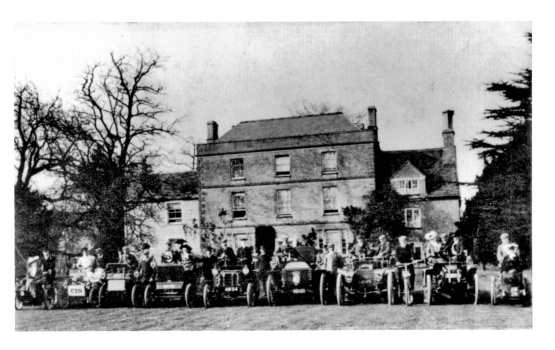

The Age of Motoring

Identified registration numbers at this motor meet shows AD42, a 12 hp Lucas double phaeton owned by John Thornton, at whose home East End House the photograph was taken. AD121, a 20 hp Wolseley, was owned by Nugent St Clair Allfrey of Williamstrip Park. Below, members of Fairford Classic Car Club, founded in 1987, display their cherished motors in the Walnut Field in 2010. The club supports a huge range of fund-raising events each year.

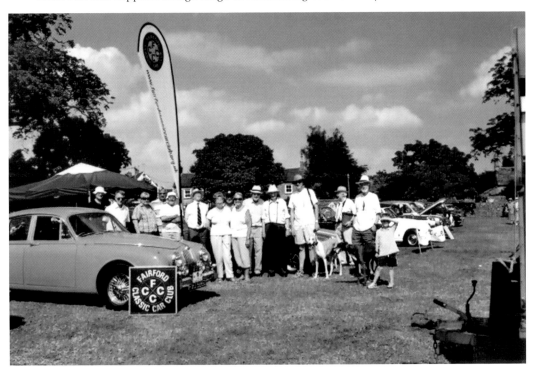

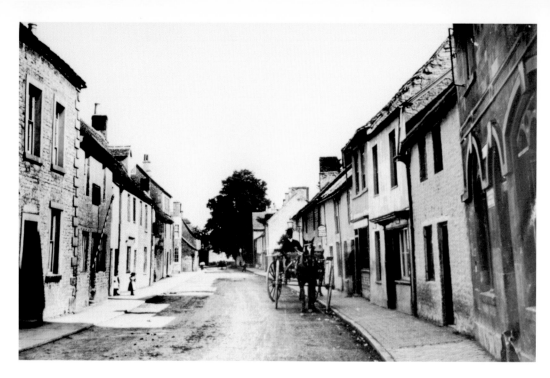

London Street

This old coaching route through the town has seen many changes – a noticeable result of modern transport. The above scene of *c.* 1905, viewed from the Market Place end of the route, is unusually quiet. Note the barber's striped pole on the second building from the left. Unusual, too, for there to be so few cars in the same view in 2011.

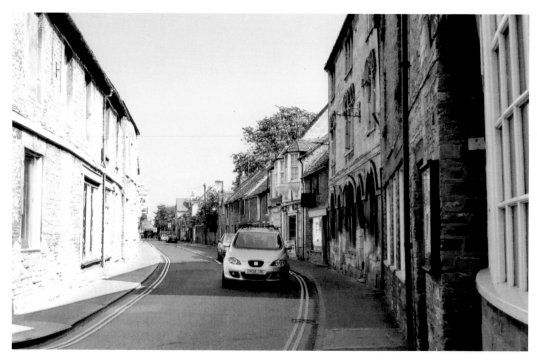

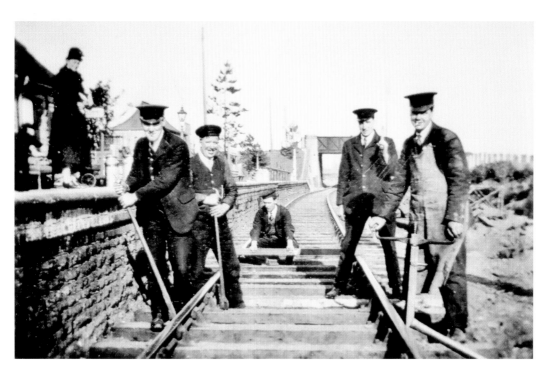

The End of the Line

The railway came to Fairford in 1873 as a single-track line to Witney, where it joined a double-track line to Oxford. It was invaluable for troop and goods movement during wartime, but closed in 1962. The road bridge in the background has long since gone. There is no trace of the old station today, with Paul Timber Engineering's works filling the site, here viewed from the spot where the old turntable stood.

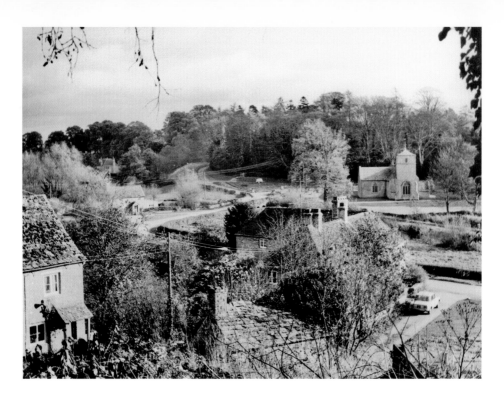

Eastleach: A Village with Two Churches

Now simply called Eastleach, this was two parishes until the 1920s. Eastleach Martin, or Bouthrop (to use its older name), with its ancient church founded by the Norman Richard Fitz Pons, can be seen above. It is joined to Eastleach Turville (which has an early fourteenth-century saddleback tower, shown in the bottom picture) by a road bridge and footbridge over the River Leach.

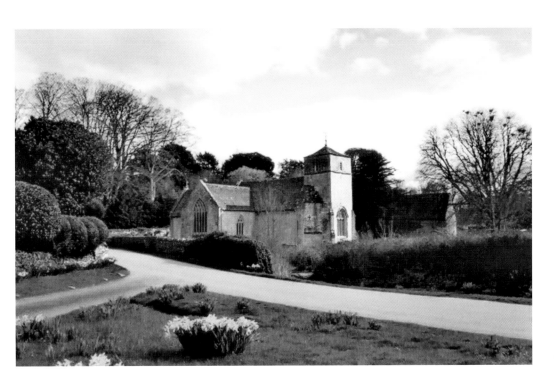

Keble Connections

John Keble, the eminent poet-cleric, and acknowledged founder of the Oxford Movement, was curate of both churches in Eastleach from 1815 to 1825. Keble College Choir sang at St Martin's church (viewed above from the road bridge) at a service commemorating John Keble's bicentenary.

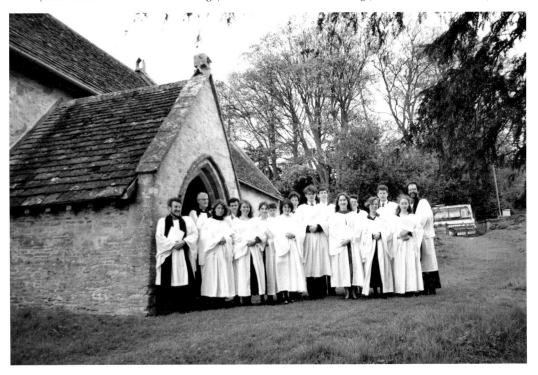

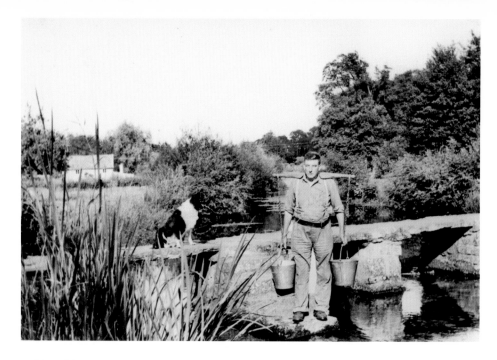

Keble Bridge

Bill Monk, who lived at Bridge Cottage (seen here in the background) with his faithful collie, Dinah, is pictured here in the 1960s fetching water from the river, as generations of Eastleach folk have done over the ages. The clapper bridge is generally known as Keble's Bridge. John Keble's ancestors held the manor of Eastleach Turville for five generations from the Tudor period.

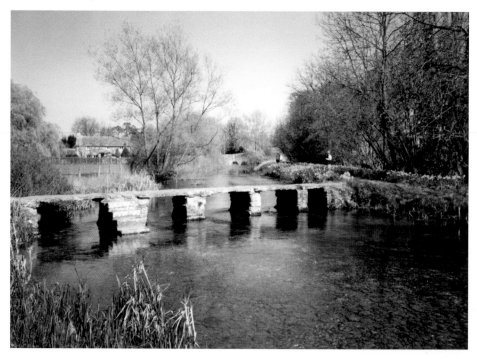

The Victoria Inn

Called the Three Horseshoes until the name was changed to the Victoria in 1840, this old inn has served the village for centuries. It is perched on the top of the three levels that give Eastleach its charm. Today's picture closely resembles the top one of *c.* 1920. The wooden seat in the foreground, commemorating the Silver Jubilee of Elizabeth II, is a welcome resting spot for the many walkers that come this way.

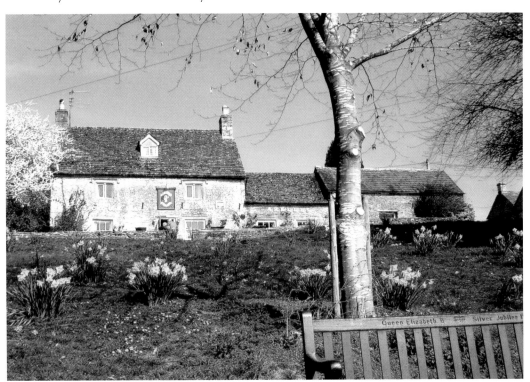

All the Fun of a Village Affair

At the Whitsun Frolics of 1958 the Revd Squire is downing a pint in a wheelbarrow pushed by his son, Martin, who is still at the centre of village affairs over half a century later. Martin was attracting customers to his Woodlice Derby at the Eastleach Fête in 2010, a village event that attracts visitors from far and wide.

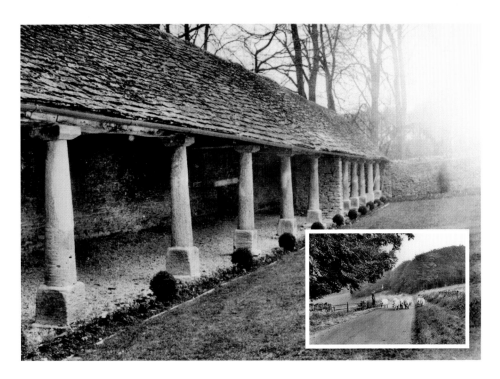

Sheep and Pigs along a Roman Way

Stone Roman pillars at Sheephill Barn on the ancient Akeman Street, between Eastleach and Hatherop, make an impressive support for what was a shelter for livestock before the barn was converted into a house. Inset, pigs are on their way to the barn using the roadway just above the valley. The valley bottom leading to Macaroni Farm is sheep country.

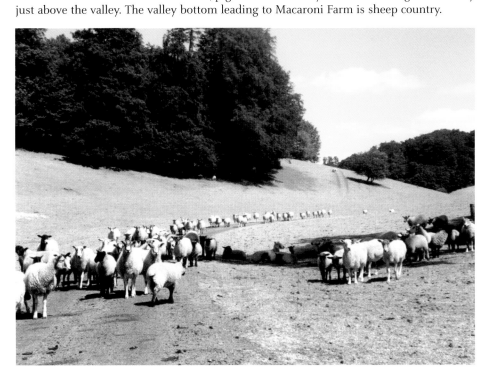

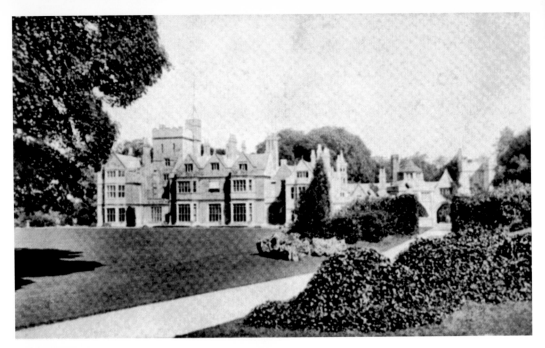

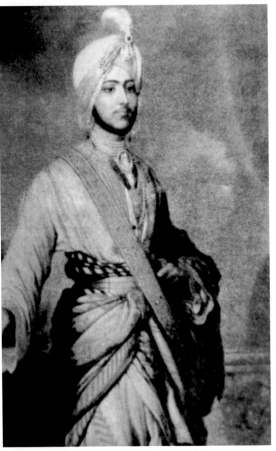

Hatherop Castle

A mainly Elizabethan structure with even older foundations was partly rebuilt in 1850. Hatherop Castle is now a prestigious private school. It has a long history of interesting family ownership and was requisitioned during the Second World War for SOE officer training. One of its briefest and most colourful occupants was the Maharajah Duleep Singh, heir to the wealthy Sikh Empire, who had been brought to England as an eleven-year-old after the British annexed the entire kingdom. Referred to as the Black Prince, the Maharajah came to Hatherop Castle in 1862, but stayed only a couple of years.

Schooldays of Yesterday

Already a rarity by 1988, this old-type school sign was spotted by Andrew and Gemma Mason at the top of Hatherop Hill before the approach to Hatherop Castle School. The stone wall behind them is part of the boundary wall enclosing Williamstrip Park estate, seat of the Hicks-Beach family for generations. Below, Hatherop village schoolchildren in a motley of hand-me-downs, *c.* 1910.

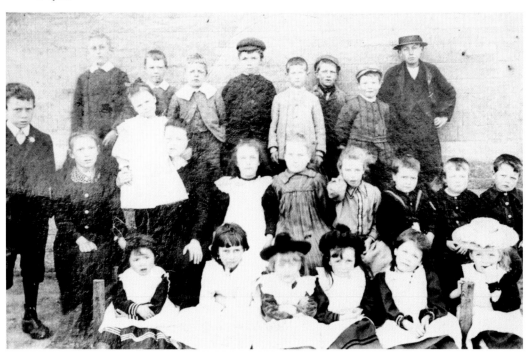

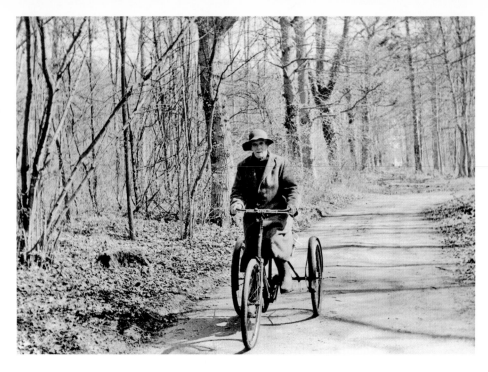

The Last 'Knight of the Road'

Charles John, or John Charles, (he wasn't sure which way around his name should be) on the old tricycle, bought for him by the girls of Hatherop Castle when he could no longer tramp the roads doing the odd job to buy enough food to survive. They also bought a shepherd's hut in Macaroni Wood, where he lived in the 1970s. Below, pastoral peace along the public footpath from Coln St Aldwyns to Bibury.

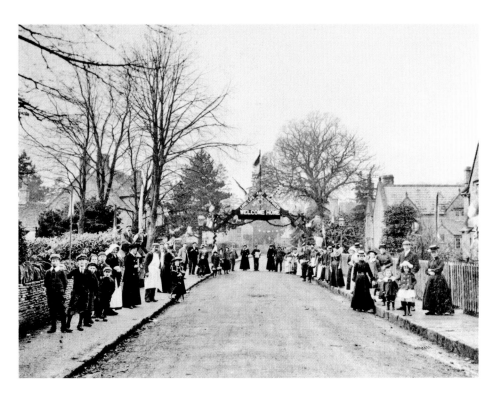

Welcome and Walling

The whole village turned out to welcome Mr Gardner Bazley and his bride home to Hatherop Castle after their wedding in 1902. Below, the rebuilding of the dry-stone-wall boundary of Williamstrip Park estate is undertaken by Paul Selway, with Giles Drew and Luke Hodges. The ancient craft involves, as Paul says, 'puzzles and patience'. It can only be done manually, and the team managed to build about 3 metres of the 2.3-metre-high wall each day.

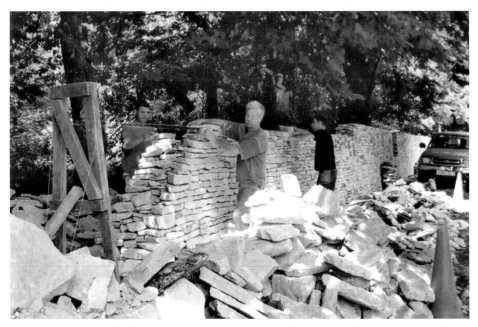

Village School and Castle Gardens

Hatherop Church of England Primary School was built in 1856 by A. G. Ponsonby as a memorial to his father, Lord de Mauley of Hatherop Castle. Pupils from Quenington and Coln St Aldwyns have increased the numbers since their own schools closed in the 1970s. Below, Pati Weston in the walled gardens of Hatherop Castle, where she runs the Garden and Plant Company with her husband, Jeremy.

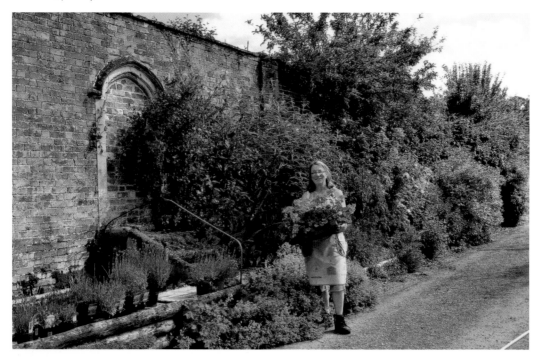

Coln St Aldwyns

The New Inn (above in 1910, below in 2011) was once a grocer's shop selling beer, but became an inn in 1899 and became the focus of national attention when it was sold in 1988 to property developers. The Coln St Aldwyns Society was formed, raising some £100,000 to fight the closure of the pub; thanks to the monumental efforts of the community, the battle against development was won and the New Inn re-opened in 1991.

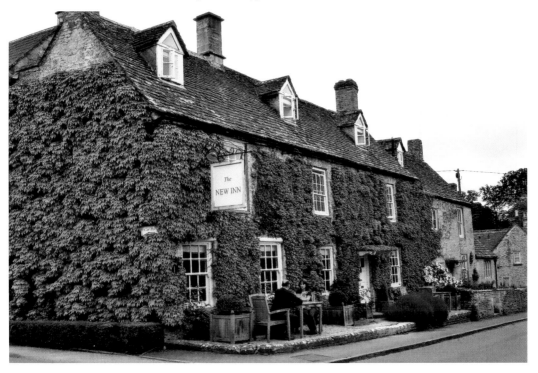

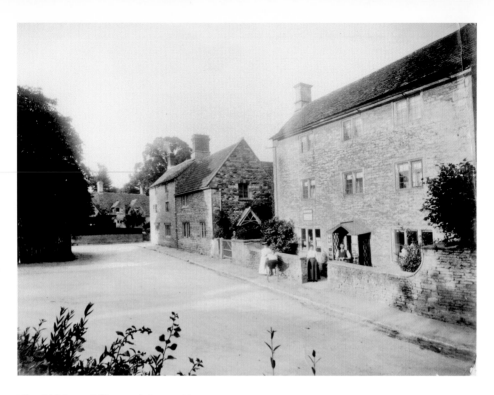

The Old Post Office and Sweet Shop
There have only been small changes between 1908 and 2011. The trellised porch where the man is standing has been replaced by a stone-built one, reflecting the style of the old telephone kiosk. The garden wall has been replaced by railings since the old Coln St Aldwyns Post Office and Stores reverted to a private residence.

The New Post Office and Stores

Coln St Aldwyns Post Office and Stores also serves the neighbouring villages of Hatherop and Quenington, but moved to the other side of the road at the top of the hill in 1993. Little has changed between 1937 and 2011. Older residents will recall it as the Co-op, but no-one now remembers when the village bath tub was housed in one of the outbuildings, costing 3*d* on Fridays.

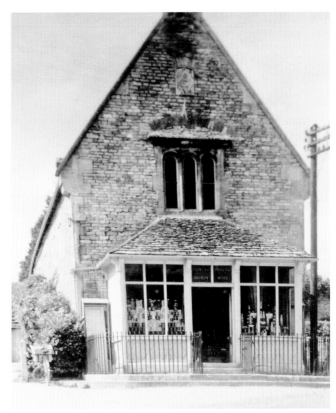

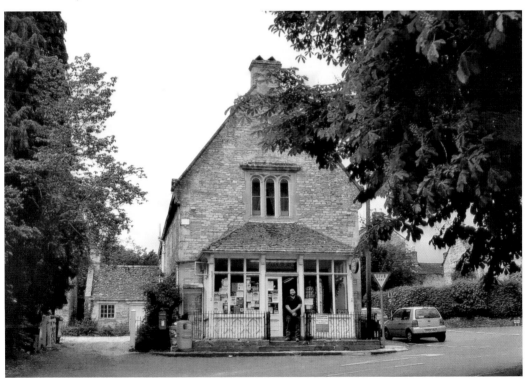

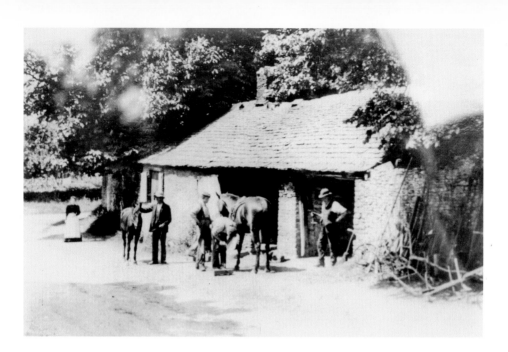

The Old Smithy

1905 – the old smithy at the foot of Hatherop Hill by the road as it bends to the valley and up to Coln St Aldwyns. Charlie Bartlett carried on as the village blacksmith with a forge moved back from the roadside. As demand for farriery work declined, Charlie, later succeeded by his son Dennis, turned to ornamental ironwork, with a speciality line in weathercocks. The forge closed in the late 1980s.

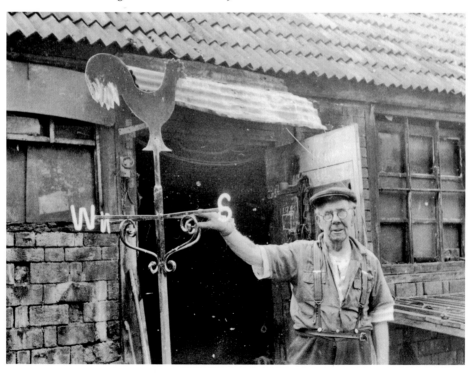

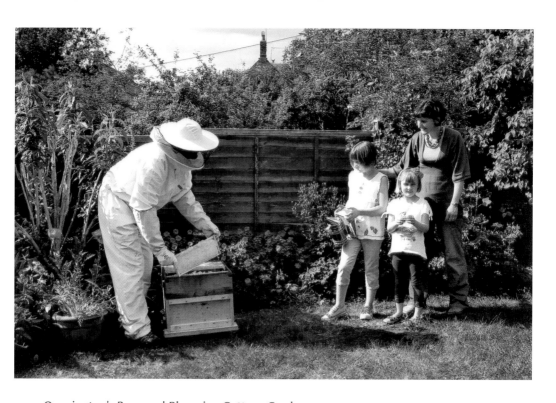

Quenington's Busy and Blooming Cottage Gardens

There seems to have always been a beekeeper somewhere in Quenington. Here, Robert Youngs removes a frame from a hive. He ensures the girls are standing well back and Poppy is ready with a smoke gun, just in case. Below, Mrs Kathleen Scott's cottage garden at Donkeywell attracts the attention as here of Dr Bernard and Gerry Cotton, who marvel at the vibrant bed of dahlias.

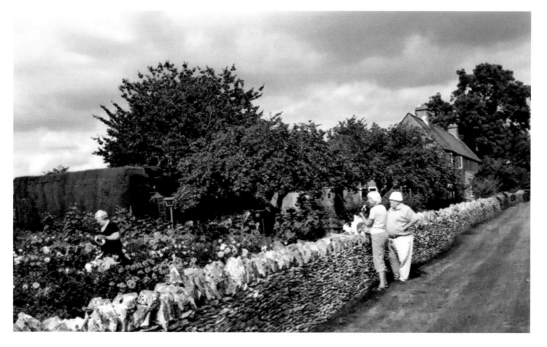

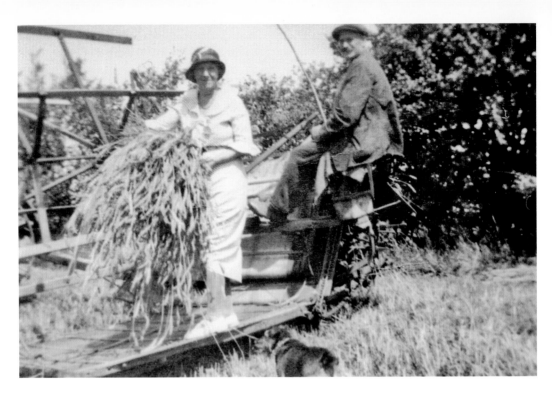

Down on the Farm

Judging by the lady's dress, this picture of harvesting at Coneygre Farm was probably taken in the 1930s. Below, Chris Peachey prepares to take a trailer-load of Fairford and District U3A members on a tour of Donkeywell Farm in 2010 to show them how farming practice has changed to meet the demands of the twenty-first century.

Godwins of Quenington

Godwin Pumps – known as H. J. Godwin until 2000, as displayed here at their trade stand at the Three Counties Show in 1936 – started business as a building firm in 1865 (the company built the bank in Fairford) and developed into an internationally known pump manufactory. By the mid-1950s, H. J. Godwin was the largest employer in the area, with many of the 150 workers cycling in from Fairford and neighbouring villages, where the factory hooter could be heard signalling the start and finish of the day's working hours. The aerial view gives an indication of the size of the factory. It suffered Gloucestershire's worst-ever fire on 17 May 1980. Rising like a phoenix from the ashes, H. J. Godwin built a new factory on the paddock of H. J. Godwin's old house and was back in the world market before the end of the decade.

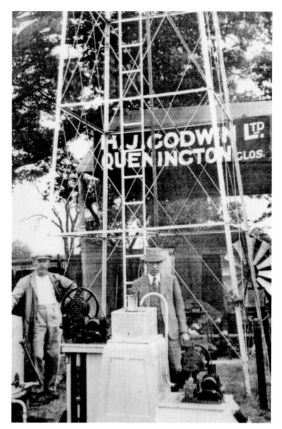

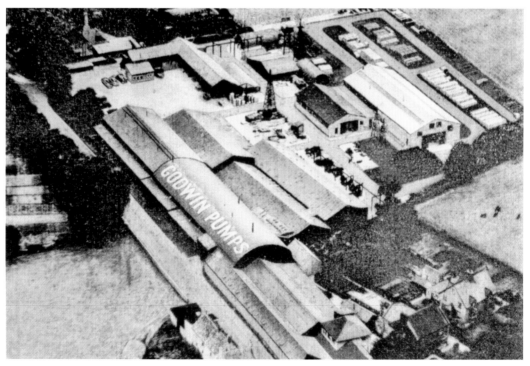

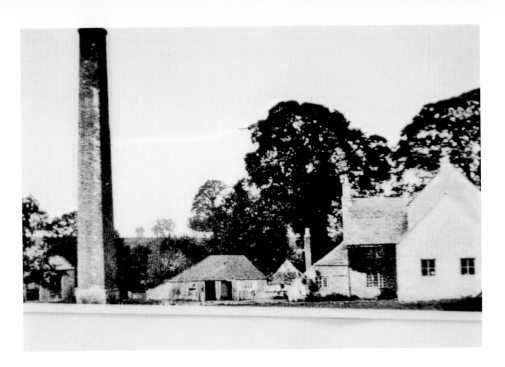

Paper Mill and Smallest Pub

Quenington Paper Mill (above) was one of some three dozen paper mills in the Cotswolds in the eighteenth century. Owned by Joshua Corby Radway in 1830, the mill stood at the foot of Rag Hill, named after the cartloads of rags that made their way down to the works. Below, The Earl Grey, now closed as a pub, once held the record as the smallest bar in Britain at 12 feet 3 inches by 9 feet 6 inches.

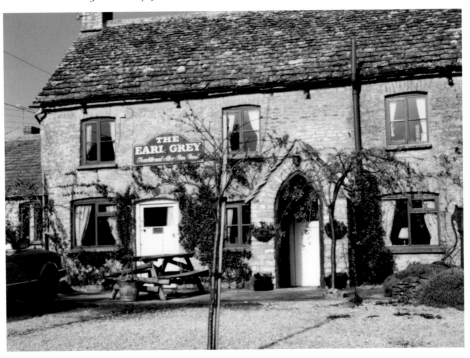

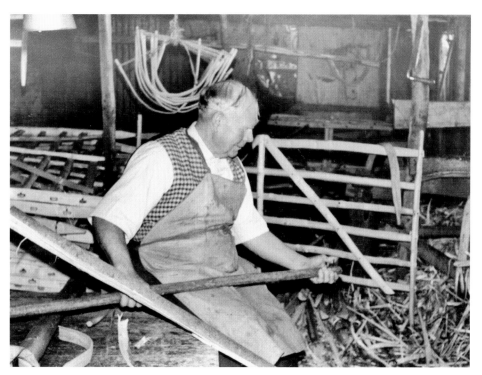

Timeless Skills in Arts and Crafts

'Kim Elliott is my name, with my hand I wrought the same. Quenington.' The tiny sampler that Dr Elliott stitched with these words hangs on an inside wall of the model cottage that she is holding outside her cottage in 1983. Dr Elliott's exquisite work has been exhibited throughout the country and her status as an artist in embroidery is legendary. Above, Alec Twinning, the last of the local hurdle-makers, was still plying his ancient trade in the 1980s in the same shed behind the stables in Coneygre Road that had been his workshop since 1938. For many years, university students and television reporters tried to learn from him the secret of the craft. I suspect it is something to do with the dignified peace and satisfaction that is the country craftsman's right.

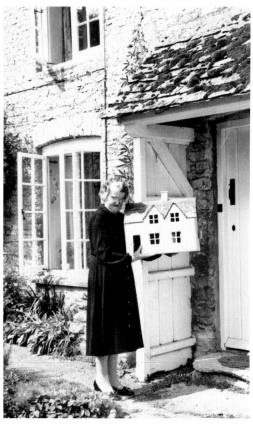

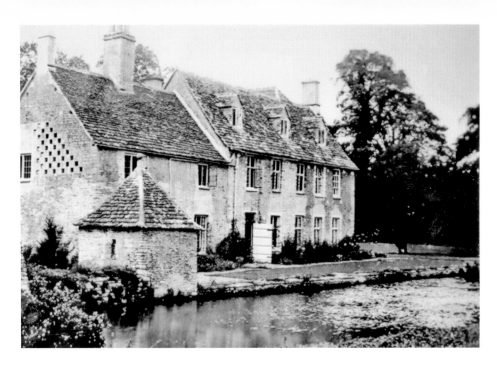

Bridging the Centuries at the Old Rectory

In its enchanting riverain setting, the Old Rectory has been the pivotal force of village life since it became David and Lucy Abel Smith's home some twenty years ago. However, it is for the beautiful gardens and the amazing innovations within the house itself that the art world beats a path to their door. Below, Lucy and David and their daughter Eliza at the swing bridge designed by Richard La Trobe-Bateman.

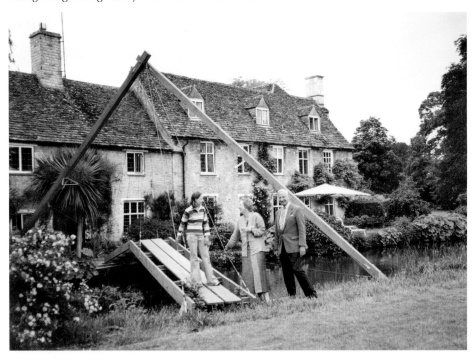

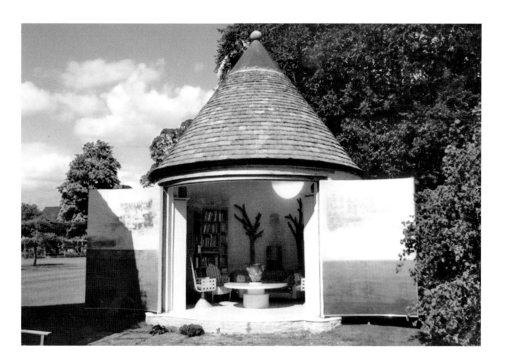

Sculptural Fun and Classic Design by the Coln

The quiet waters of the Coln, which runs in front of the Old Rectory, add a living theatrical backdrop to the biennial sculpture show Fresh Air, which David and Lucy Abel Smith founded some two decades ago as an open-air showcase for contemporary artists. Above, the latest addition to the old house is this stunning detached library, echoing the circular dovecote structures so typical of the Cotswolds; the swing-open doors are lined with pastoral shaded textiles.

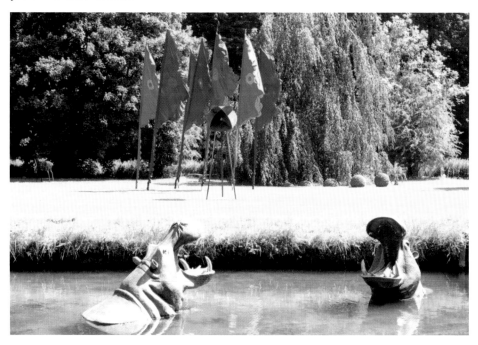

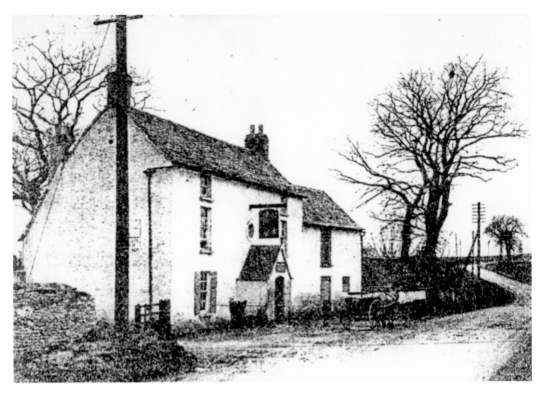

The Three Magpies

Equidistant from Fairford and Meysey Hampton, the Three Magpies pub, closed now for many years, seems to be caught in a time warp. The photograph above was taken a century ago, looking east to west. Below, Andrew Hoskins from New Zealand, on a painting tour of his home area in 2009, gives the mysterious old building a more magical touch in his watercolour, which looks west to east.

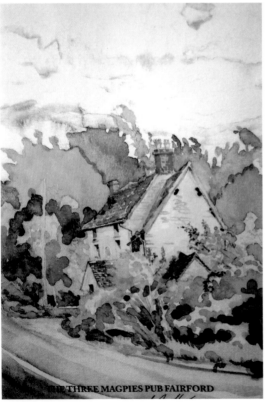

THE THREE MAGPIES PUB FAIRFORD

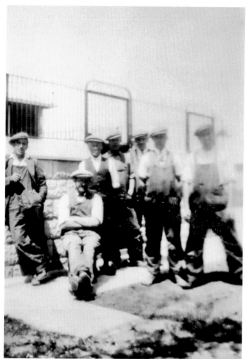

Meysey Hampton

Below, the VWH Hunt brings a touch of Old England to a spring morning in 2011 as they set off from the Kennels, built by Baldwins of Fairford. Above, Ted (Pop) Morse, the master mason, is pictured (sitting, top right) with his team at the completion of the project in 1934. They were congratulated by the master on the excellence of their work, which took little more than nine months to complete at a cost of around £8,000.

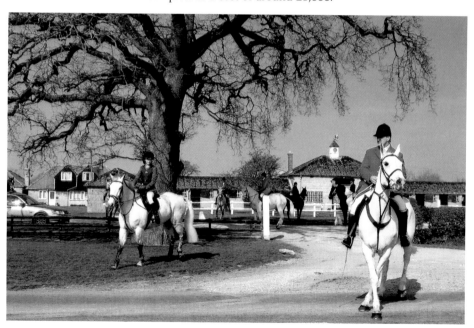

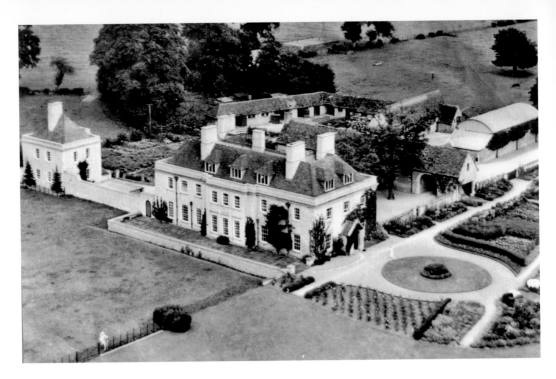

South Hill

After South Hill House was demolished to extend Fairford airfield, the cricket team, drawn initially from the estate workers, moved to Meysey Hampton, taking their name with them. Here, in 1969, at a match to commemorate the 700th anniversary of the church, the Bishop of Gloucester joined the team. *Back:* L. Herbert, J. Houghton, I. Wells, A. Cotterell, M. Cuss, C. Clive, M. Thompson, D. Lawrence. *Front:* G. Millard, G. Wells, Bishop B. Guy, I. Higgs.

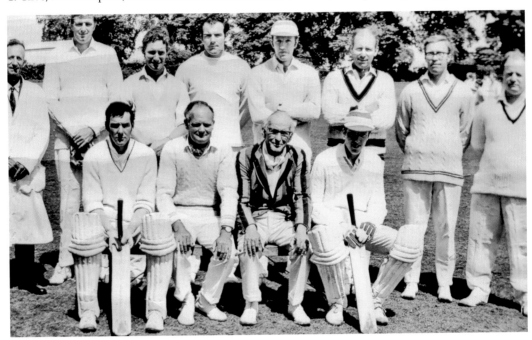

Meysey Hampton School

Above, a little girl has the big task of planting a cherry tree to mark the centenary of the village school in 1972. Extensions to the Victorian building and playground since then give today's pupils something to skip about, as captured here in June 2011.

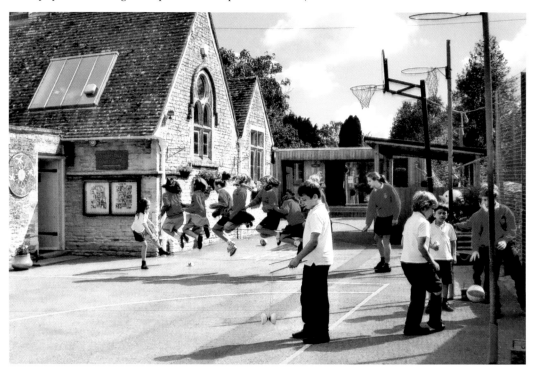

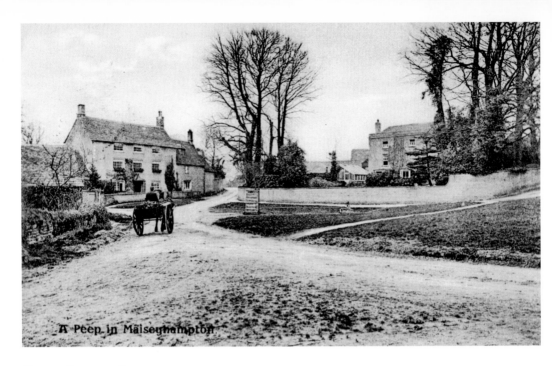

Meysey Hampton Green

The bleakness of winter in the top picture affords a wide-open 'peek in Maiseyhampton' (the alternative spelling used for many years). The Georgian manor house can be clearly seen at the back of the Green. Villars Farmhouse to the left and the Green itself – complete with a village pump raised on stone steps – have not changed at all, except for the welcome sign of spring in the picture below, taken from the other side of the Green.

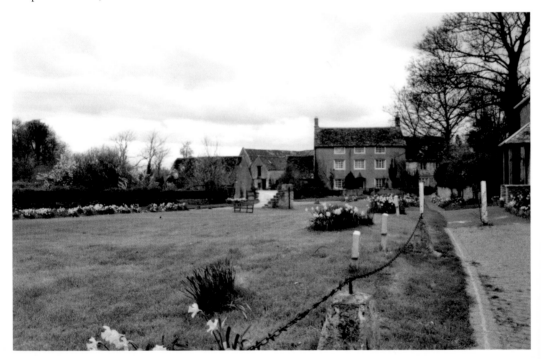

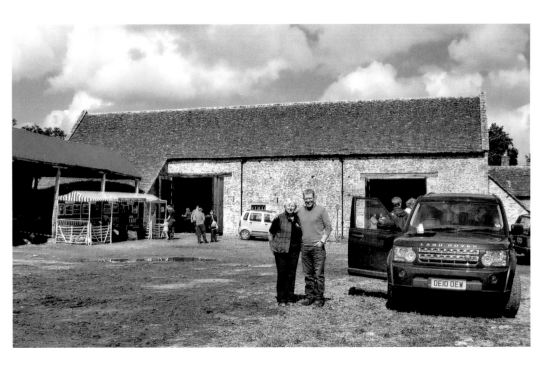

A Starring Role in TV's *Countryfile*

Adam Henson, star presenter of *Countryfile*, talks to the spinners and knitters competing in the 17th International Back to Back Wool Challenge in May 2011. The challenge to knit a garment with wool shorn from the sheep's back and spun on the same day was first held 200 years ago. Above, Adam is with Margaret Pursch, a prominent member of the Cotswold Sheep Society who organised the event, outside the magnificent barn at Villars Farm where the event took place.

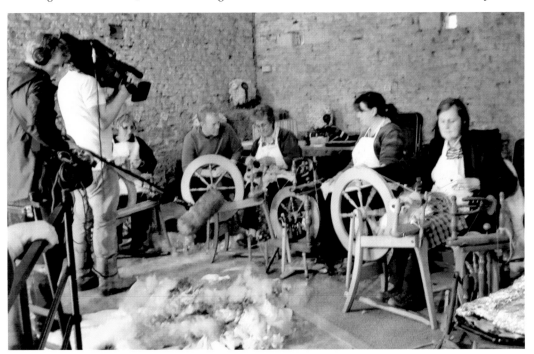

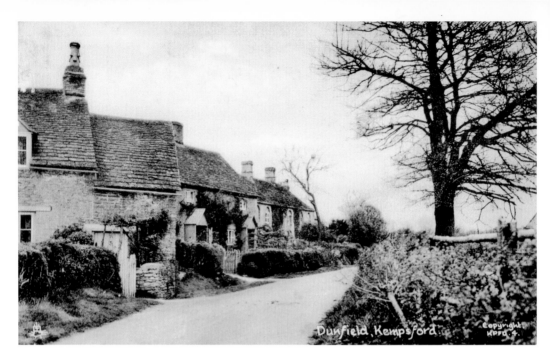

Kempsford

Dunfield, a pocket hamlet of Kempsford. Since this postcard picture was taken it has edged towards the perimeter of Fairford Air Base, but it still retains its old-time cottages. Dunfield was home to Michael Lyne, the prominent hunting-scene artist who died in 1989. Michael Lyne was a man of the hunt, and the liveliness and excitement of riding horses was captured in his paintings. Here he is at work in his studio.

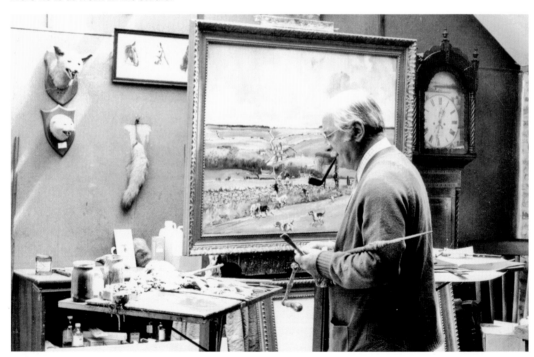

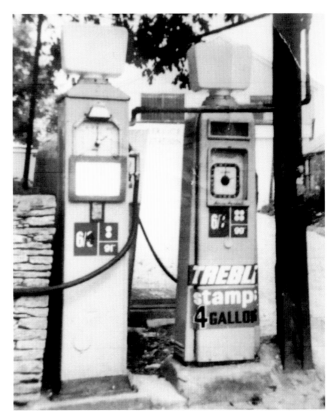

Shillings and Stamps at the Petrol Pumps

The petrol pumps and garage workshop of pre-decimal days have disappeared from Kempsford's long village street, along with the baker's and grocer's shops. New houses now fill the site where the garage workshop stood.

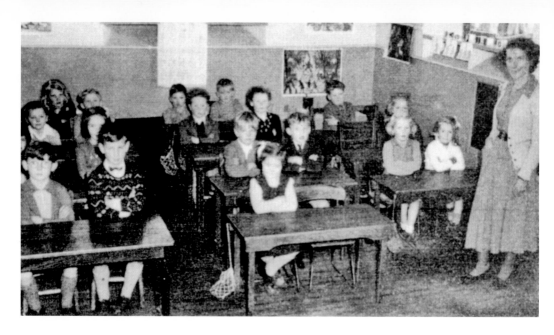

Schooldays at Kempsford

It is quite unusual to come across a photograph taken inside a school classroom, so the picture above is valuable insofar as it shows not only the dress of the 1950s, but also the rigidity and formality of how the children posed for the photographer, arms folded on their desks. The children of 1989, seen below, look much happier. They are informally grouped around their teacher in a classroom bright with pictures and teaching aids.

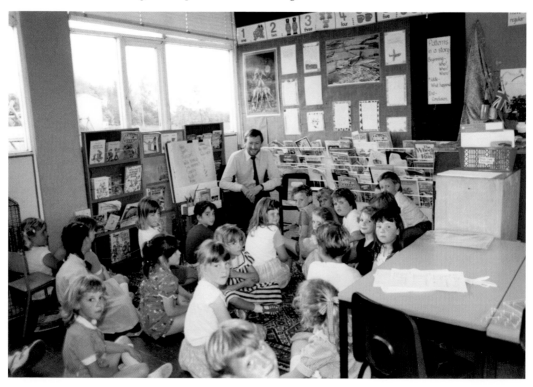

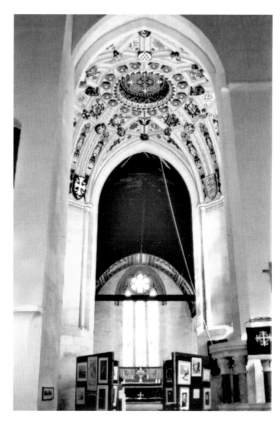

Lancastrian Ties at St Mary's

The centre of this magnificent vaulted roof is circled with sixteen red roses of Lancaster, commemorating the church's historic ties to the Lancastrian family, who owned the castle that stood just south-west of where the church now stands. Tradition has it that the horseshoe nailed to the church door was cast by the 1st Duke of Lancaster's horse as he fled from the village after his small son drowned in the ford.

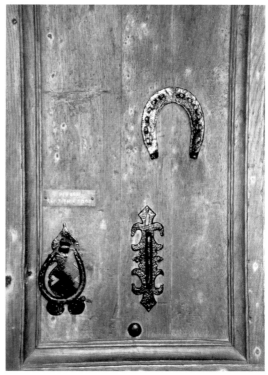

Wharf House

Built in 1789 as the agent's house on the Thames & Severn Canal, Wharf House was semi-derelict by 1998, when the picture above was taken. The hut in the foreground was where tolls were handed over and the canal workers were paid. The family at the front door in the 1914 photograph below shows George Strange, who worked as a carrier, his second wife Sarah, and Robert, the last of his twenty-seven children.

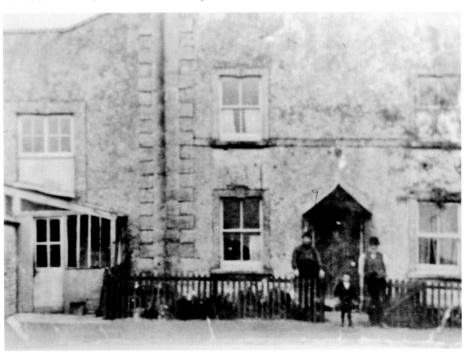

Kempsford Manor

The old canal towpath within the manor grounds is listed among the top snowdrop walks in the country. Below, cream tea on the terrace, with Chedworth Silver Band making music on the lawn – an idyllic, quintessentially English summer scene. The annual church fête is one of the many fund-raising functions that Mrs Ipek Williamson hosts at the lovely old manor.

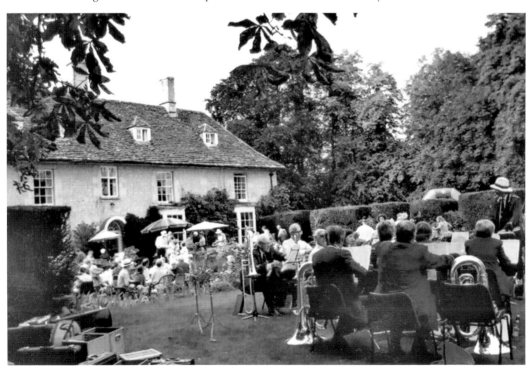

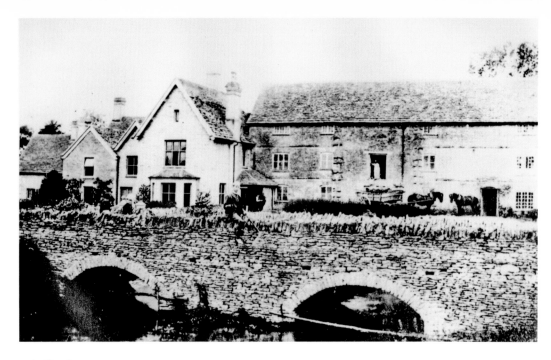

Whelford

A mill was built at Whelford beside the ford in the early twelfth century, with a bridge some hundred years later. The two-arch bridge (*c.* 1910) was built in 1851, when the mill was still working. The age of the heavy horse continued into the 1990s, when Clem Wakefield used his shire horses for some chain harrowing, but mainly for show and ploughing matches, as captured in the bottom picture.

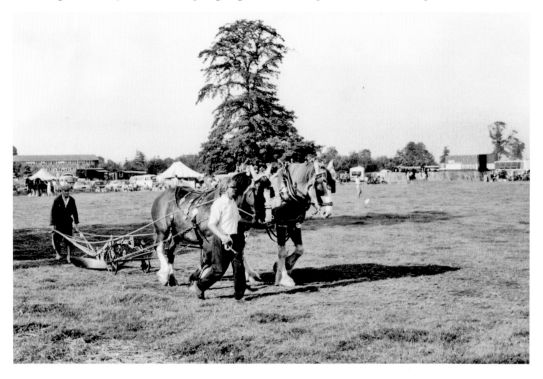

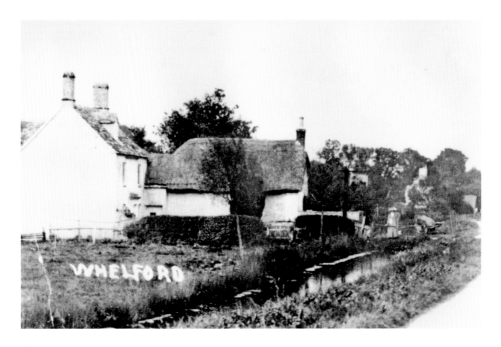

The Queen's Head

Another scene from the past, which many servicemen at RAF Fairford will remember from the war years. The Queen's Head pub, run by the Griffin family, was fronted by the feeder to the canal. Outside the pub (from left) are Albert (Curly) Legg, Harold Lanfear, Johnny Duffy, George Roberts, Flo, Nancy and Alan Griffin and Freddie Walker. The early nineteenth-century Queen's Head was demolished in 1950 for the airfield extensions and the feeder was filled in.

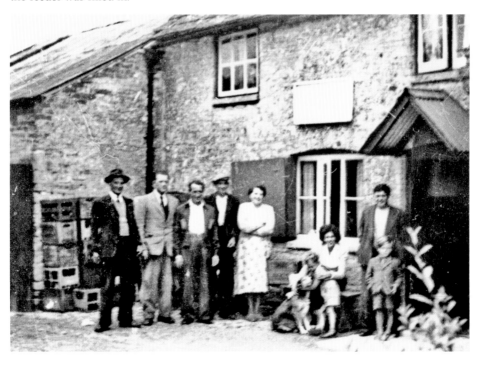

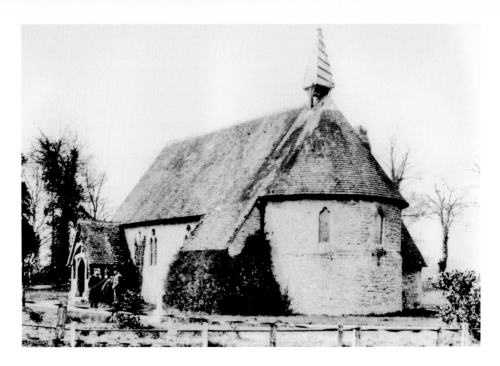

The Church of St Anne

The charming little church in Whelford was built as a chapel of ease in 1864, with no licence for wedding services, so Sarah Nicholls and Jason Braid marked a turning point in the history of St Anne's when they married here on 30 April 2011. Sarah, who was brought up at the Hermitage, successfully sought to get the church licensed. On the day she simply walked through an attractively cut arch in the garden hedge to her wedding at the church next door.

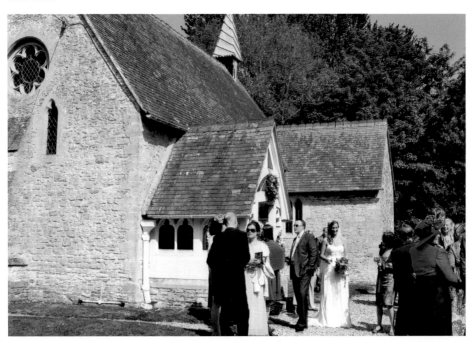

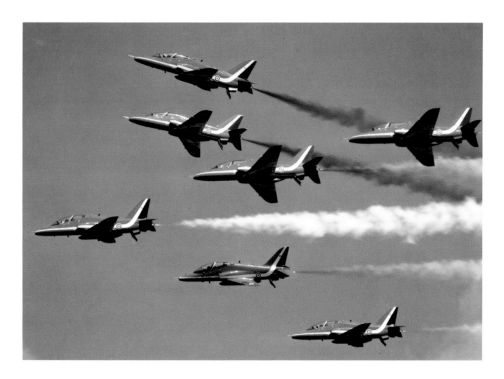

Flying Over (and Farewell to) Fairford

The legendary Red Arrows aerobatic team on a fly-past at the Royal International Air Tattoo of 1995. They hold a special place in the hearts of local people as they were based many times in the Cotswolds. Below, a poignant moment at the farewell ceremony held at the Heritage Day in 2010 to mark the withdrawal of the 420th Air Base Group from RAF Fairford. American servicemen had been stationed there on and off for fifty years.

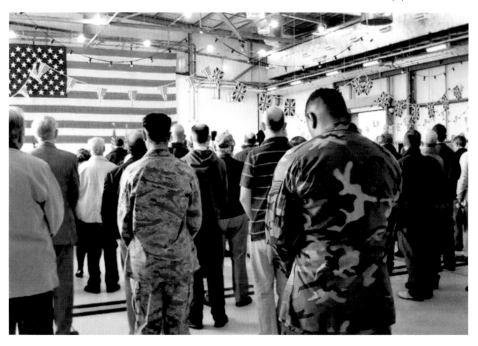

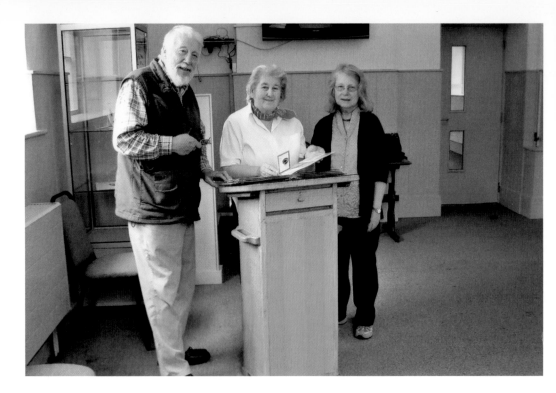

Fairford History Society
The author (centre), president of Fairford History Society, with Geoff Hawkes, chairman, and Alison Hobson, secretary, in the Heritage Room at Fairford Community Centre. The society is recognised as one of the most successful and vibrant in the county, due to the professional dedication and hard work of its members – to whom, along with my husband Ralph, this book is dedicated with loving pride.

Acknowledgements

I am grateful to many people and organisations for their help and support in so many ways, especially the following, who have so kindly lent me their precious photographs for reproduction in this book: David and Lucy Abel Smith, Ana Bianchi Evans, Randy Bryan Bigham, Hugh Brewster, Peggy Bridges, Mary Chick, Mark and Lorraine Child, Gill Coombe, Mark Cowley, Rita Cross, Primrose Croteau, *Gloucestershire Life*, Tracey Hill, Alison Hobson, Piers Hobson, Andrew Hoskins, E. Koningsveld (courtesy RIAT), Julian and Sonia McDermott, John Miller (Godwin Pumps), Peter Mulcock, David Perry, Anthony and Michael Peyman, Andy Pitts, Margaret Pursch, Martin Radway, Jenny Sandford, Pam Sayre, Heather Shuttlewood, Sgt David Smeeton, Mary Vizor and Marian Walecki.